가면무도회

Masquerade

가면무도회 *Masquerade*	국립현대미술관 과천 1원형전시실 MMCA Gwacheon, Circular Gallery 1	2022. 4. 13. – 2022. 7. 31.

관장
윤범모

Director
Youn Bummo

학예연구실장
김준기

Supervised by
Gim Jungi
Lim Dae-geun
Cho Jangeun

현대미술2과장
임대근

학예연구관
조장은

Curated by
Lim Dae-geun

전시 기획
임대근

Curatorial Assistant
Kim Youngin Arial

코디네이터
김영인

Renewal of Space Design
Kim Yongju, Yoon Jiwon

공간 리뉴얼 디자인
김용주, 윤지원

Space design prior to renewal
NOL (Namkoong Kyo, Oh Hyunjin, Lee Kwangho)

*리뉴얼 전 공간 디자인
NOL (남궁교, 오현진, 이광호)

Graphic Design
hongbaksa

그래픽 디자인
홍박사

Space Construction
Hong Jiwon

전시 조성
홍지원

Transportation·Installation
Park Yanggyu, Tak Hyeonwoo

운송·설치
박양규, 탁현우

Graphic Installation
Seojin Plan

그래픽 설치
서진기획

Conservation
Beom Daegon, Lee Nami, Cho Inae, Yoon Bokyung,
Han Yebin, Choi Yoonjeong, Choi Yangho

작품 보존
범대건, 이남이, 조인애, 윤보경,
한예빈, 최윤정, 최양호

Public Communications
Lee Sunghee, Yun Tiffany, Park Yulee, Chae Jiyeon,
Kim Hongjo, Kim Minjoo, Lee Minjee, Ki Sungmi,
Shin Narae, Jang Layoon

홍보 마케팅
이성희, 윤승연, 박유리, 채지연, 김홍조,
김민주, 이민지, 기성미, 신나래, 장라윤

Customer Service
Oh Kyungok, Chu Hunchul

고객 지원
오경옥, 추헌철

Photography·Filming
Jang Junho

사진·영상
장준호

가면무도회

Masquerade

목차
Contents

봄이 왔습니다. 자연 속에 자리한 덕분에 국립현대미술관 과천 일대는 벚꽃
동산으로 계절의 아름다움을 뽐내고 있습니다.

그럼에도 불구하고 상춘객들은 마스크를 쓰고 있습니다. 코로나19
대유행은 마스크를 쓰지 않는 것이 더 어색할 정도로 우리 삶을 바꾸어
놓았습니다. 바로 '복면시대'와 같습니다. '복면'은 '마스크'와 연결되게
합니다. 이와 같은 상황에서 국립현대미술관 과천관은 소장품으로 꾸민
특별기획전 «가면무도회»를 개최합니다.

가면은 현대미술을 관통하는 주요 주제 중 하나입니다. 현대미술
작가들의 중심에 있는 이미지의 문제와 가면은 직접 맞닿아 있기 때문입니다.
실체를 가리는 허구를 폭로한다는 현대미술의 전략 중의 하나가 곧 넓은
의미에서 가면과 연결되기도 합니다. 또한 진실을 숨기기도 하지만 동시에
역설적으로 진실에 더 가깝게 다가갈 수 있게도 하는 가면의 이중성은
작가들의 관심을 끌기도 합니다. 이 흥미로운 주제의 다양한 변주를 이번
전시에서 확인할 수 있을 것입니다.

국립현대미술관 소장품을 중심으로 구성된 «가면무도회»가
코로나19 대유행이라는 긴 터널의 끝자락에서 나누는 희망의 메시지로
받아들여지기를 바랍니다. 또한 가면이라는 주제를 표현하는 현대미술의
다양성을 널리 향유하는 기회가 되었으면 합니다. 끝으로 이번 전시에
출품해준 작가분들과 미술관 가족들, 그리고 관계자 여러분께 깊은 감사의
마음을 전합니다.

윤범모
국립현대미술관장

Foreword

Spring has come. Smiling cherry blossoms announce the splendor of spring around MMCA Gwacheon, a branch of MMCA with a focus on nature and ecology.

However, visitors to the museum are still wearing masks. COVID–19 has changed our lives so profoundly that it feels awkward whenever we don't wear masks. One might say that we are living in an 'age of veils,' which connects to the notion of 'masks.' Amid these circumstances, MMCA Gwacheon presents *Masquerade*, a special exhibition of artworks from the museum's permanent collection.

Indeed, masks are an important theme in contemporary art. Many contemporary artists engage with issues related to images, to which the mask as a subject is closely linked. One of the many strategies of contemporary art is displaying illusions that suppress reality. In broader terms, this too is related to the theme of masks and their ability to simultaneously conceal the truth and bring the viewer closer to the underlying reality. Instances of duality such as this often garner creative interest from artists. The current exhibition introduces diverse variations on this intriguing topic.

It is my hope that *Masquerade* may be appreciated as a permanent collection exhibition as well as a message of optimism at the end of our long struggle against COVID–19. The exhibition also offers an opportunity to appreciate the diversity of contemporary art through the theme of masks. Last but not least, I would like to express my sincere gratitude to the participating artists, museum staff, and everyone involved in making this exhibition possible.

Yun Bummo
Director
National Museum of Modern and
Contemporary Art, Korea

기획의 글

≪가면무도회≫

임대근
국립현대미술관 학예연구관

반갑구나, 사랑스러운 자매들아!
너희들은 어제도 오늘도
가면무도회에 푹 빠져있지만,
나는 아노라, 너희들 내일 가면 벗을 것을.
요한 볼프강 폰 괴테의
「파우스트」 중에서 '희망'의 대사

1. 가면의 안과 밖

가면은 이중적이다. 타인의 시선으로부터 우리를 멀리 떨어지게
하는 동시에 그 한 겹의 막 뒤에 숨음으로써 오히려 더 가까이 다가갈 수
있게 한다. 가면은 이미지다. 철저히 연출된 가짜. 그렇기에 그 뒤에 숨겨진
것은 언제나 궁금하다. 가리지 않았다면 정작 관심도 없었을 맨얼굴. 그러나
숨었기에 찾고 싶은 모습.

가면은 문화다. 관습과 편견으로 한껏 멋을 낸 커튼이다. 그러나 그
너머에는 여전히 벌거벗은 동물이 두 발로 서 있다. 먹이를 찾고 교미를 하고
새끼를 키우고 포식자를 피해 숨는 놀란 눈의 원숭이가 있다.

동물의 세계에도 물론 가면은 존재한다. 포식자로부터 자신을
보호하는 약자의 위장, 혹은 반대로 먹이를 노리는 포식자의 위장,
번식기에 이성의 관심을 끌기 위한 과시 등이 그것이다. 그러나 인간의
가면 너머에는 자연이 아니라 문화가 존재한다. 이 새로운 형태의 포식자는
때때로 자연보다 훨씬 더 잔인하고 어느 동물과도 비교할 수 없을 정도로
야만스럽다. 이 포식자의 집요한 시선으로부터 자신을 보호하기 위해서 혹은
은밀한 저항을 시도하기 위해서 우리 역시 가면을 꺼내 쓴다. 결국 내밀한
자신과 타인, 문화, 규범 등이 공개적으로 만나는 찰나의 지점에 가면이
존재하게 된다. 그렇다면 그 가면을 경계로 한 안과 밖이 결국 우리가 사는
세상 전부라고 할 수 있다.

이런 의미에서 많은 동시대 작가들이 이 가면 근처에 시선을 두고

있는 것은 전혀 놀라운 일이 아니다. 인간 세계의 모순과 부조리와 긴장과 유혹이 이처럼 응축된 대상이 그리 흔치 않기 때문이다. 어떤 이들은 가면을 벗겨내 볼 궁리를 하고 다른 이들은 가면의 쓸모에 대해 생각에 빠지고, 또 다른 이들은 애초에 우리가 왜 가면을 쓰게 됐는지부터 궁금해 한다. 오히려 더 많은 가면을 덧썼음으로써 우리에게 가면의 존재를 새삼 의식하게 하는 이들이 있고, 가면을 벗기면 드러날 우리의 벌거숭이 모습을 대뜸 눈앞에 들이미는 이들도 있다. 많은 작가들의 시선이 이렇게 끊임없이 가면으로 향하는 것은, 소재나 방법을 막론하고 어떤 의미에서 결국 현대미술이란 이 가면에 대한 생각일 수 있기 때문이다.

2. 현대미술과 이미지

인간이 스스로를 짐승과는 다른 존재로 여기면서 본능과는 다른 무언가 추상적인 것들을 고안해 낸 이래, 보이지 않는 수많은 것들이 만들어지고 정교하게 다듬어져 왔다. 관념, 관습, 도덕, 담론, 역사, 종교, 민족, 국가 등 지금 우리에게 익숙한 거의 모든 것들이다. 이 중 어떤 것도 실제로 만지거나 볼 수 없기에 우리 집 고양이에게는 보여줄 수도 가르칠 수도 설득할 수도 없다. 이 어려운 과제를 위해 인간의 두뇌가 고안해 낸 것이 이미지다. 예를 들어 '효'라는 것을 생각해 보자. 당신은 순수한 정의로서 효의 개념을 떠올릴 수 있는가? 생각해 보려고 잠깐 멈춘 순간, 인당수에 몸을 던지는 심청 혹은 동네에 칭찬이 자자한 어느 집 아들의 이미지가 즉시 떠오를 것이다. 혹은 '대한민국'의 그 순수한 개념 그대로를 생각하려고 노력해 보라. 아마도 그 즉시 태극기에서부터 백두산 천지에 이르기까지, 영화 「국제시장」식 격동의 현대사 이미지가 주마등처럼 지나갈 것이다.

실체가 없기에 이미지들은 연약해야 마땅한데 우리 모두 알다시피 실제로는 그 반대에 가깝다. 상상력이라는 독특한 사고 작용에 힘입어 인간들은 이 이미지들에 엄청난 힘, 심지어 본능조차 가볍게 넘겨버릴 정도의 힘을 부여한다. 도덕심, 애국심, 혹은 종교적 신념을 위해 기꺼이 목숨을 던진 사례는 셀 수도 없다. 이미지는 오히려 실체가 없기에 더 많은 이들이 무한대로 복제, 공유할 수 있으며, 그 집합적인 성격으로 인해 더욱 파괴적인 힘을 갖는다. 만약 우리 고양이가 말을 할 수 있다고 해도 내가 「로미오와 줄리엣」 이야기를 들려준 뒤 사실은 잠시 후 나올 사료보다 사랑이 훨씬 더 소중한 거라고 말을 건네면 어떤 표정을 지을지 눈에 선하다. (사실 이 표정조차 나쓰메 소세키(Natsume Sōseki) 같은 인간들이 창조한 또 하나의 이미지에 불과하다.)

실체가 없어서 오히려 생겨나는 권력은 대항하기가 매우 까다롭다. 전선도 너무 광범위하고 전황을 가늠하기조차 어렵다. 이렇게 한 치 앞도 분간하기 어려운 전쟁의 최전방 참호에 진을 치고 있는 이들이 있으니 그중 하나가 현대미술 작가들이다. 마르셀 뒤샹(Marcel Duchamp)이 변기를 전시장에 가져다 놓음으로써 소위 '고상한' 체 하는 미술의 이미지를 전복시킨 이래로, 20세기를 지나 21세기에 이르도록 이 전쟁은 여전히 치열하게 전개되고 있다. 페인트를 흩뿌리든, 콜라병을 찍어내든, 텔레비전을 쌓아 올리든, 발가벗은 채 사람들 앞에 나서든, 그들이 전위를 자청한 전선 너머에는 어김없이 국가, 종교, 이념과 같은 거대한 이미지부터 개인적인 기억과 상처 같은 내밀한 이미지에 이르기까지 우리를 지배하고 옭아매는 이미지들이 존재한다. 의식하든 하지 않든 작가들의 궁극적인 관심은 결국 '미술'이라는 이미지 그 자체를 포함한 상상할 수 있는 모든 이미지, 권력을 가진 모든 이미지의 파괴에 있다고 해도 과언이 아니다.

그러나 이 작가들 손에 들린 무기 그 자체 또한 이미지이기에 이 모순적인 전쟁에서 그들이 승리하는 것은 절망적일 정도로 요원해 보인다. 누군가가 결국 이미지의 견고한 성벽에 약간의 흠집을 내는 전과를 올렸다 하더라도, 머지않아 바로 그 자신이 다음 세대의 작가들에게 다시 저항의 대상, 즉 또 다른 이미지가 되어버리는 것도 이 때문이다. 결국 현대미술의 역사라는 것 역시 이런 전복과 전복의 이미지로 켜켜이 쌓아놓은 또 다른 이미지의 성이다. 그러나 누가 알겠는가. 이들의 전투에 자극받아 후방의 우리들까지 각자의 방식대로 참전하고 결국 그로 인해 이미지 뒤에 숨은 실체가 만천하에 드러나는 그날이 언젠가 오고 말런지도 말이다. 지금 이 순간에도 내 머릿속에는「매트릭스」연작의 대미를 장식하는 해방의 '이미지'가 떠오른다. 심지어 그 영화 안에서조차 의심의 여지를 남기는 바로 그 이미지. 결국 실체가 어딘가에 반드시 있을 거란 믿음 그 자체가 또 다른 이미지일지도 모르기 때문이다.

3. 무도회로의 초대

이번 《가면무도회》에서 말하는 가면은 실체를 가린다는 의미에서 이미지의 또 다른 표현이다. 현대미술을 이미지에 관한 이미지라고 할 수 있다면 현대미술은 가면에 관한 가면이라고도 말할 수 있다. 가면을 벗겨낼 때 감춰진 실체가 정말 드러나는 것일까? 혹은 오히려 가면을 수없이 덧씌울 때에 비로소 드러나는 것은 아닐까? 이 가면은 누군가 우리에게 씌운 것일까 아니면 스스로 기꺼이 쓰게 된 것일까? 실체를 가린다고 하지만 가면 그

자체가 과연 보이기는 하는 걸까? 어쩌면 벌거벗은 임금님처럼, 그리고 그를 숭배하던 군중들처럼 우리는 보이지 않는 가면에 가려 정작 보이는 모습을 못 보는 것은 아닐까? 전시실을 떠나는 관객들의 뇌리에 이런 수많은 물음들이 스쳐가길 바라는 마음으로 《가면무도회》는 기획되었다. 또한 전시실 진입로에 설치한 영상작업과 벽면의 그래픽들은 대중문화에서, 특히 영화에서 다뤄진 가면의 이미지들을 집약적으로 보여준다. 이는 전시실을 들어서거나 나서는 관객들이 현대미술이 다른 가면과 대중에게 친숙한 가면의 이미지들을 한 번 더 비교할 수 있도록 의도한 것이다.

국립현대미술관 소장품 34점과 미술은행 소장품 3점, 그리고 작가 및 개인 소장 4점 등 총 41점이 전시된 1원형전시실은 가면무도회라는 축제적 특성과 원형 구조라는 공간적 특성을 감안하여 특정한 유형이나 주제로 구획하지 않았다. 그럼에도 마치 무도회장에서 결이 맞는 이들끼리 여기저기 모여서 얘기를 주고받듯이 주제 혹은 태도를 공유하는 작업들이 자연스레 느슨하게 모여 있을 수 있도록 배치한 것이 특징이다.

3-1. 가면 vs. 민낯

시간을 상징하는 괘종시계 위에 구체관절 인형이 어린아이와 해골이 뒤엉킨 가면을 쓰고 앉아있는 김영균의 〈비슈누아〉(2011)는 마치 이 무도회장에 들어서는 모든 이들에게 조만간 축제가 끝나고 그 가면을 벗을 날이 오고 말리라는 '메멘토 모리'의 경고를 우리에게 던지는 것 같다.

붉은 휘장을 걷고 들어선 전시실 초입에서는 육명심의 사진 두 점 〈제주도〉(1982/2017)와 〈장승 시리즈-전라남도 여수 잠ול동〉(1987/2017), 권진규의 〈마스크〉(1960년대), 그리고 석창원의 〈자화상〉(2006-2013) 연작을 만날 수 있다. 이들은 모두 전통적인 가면의 이미지나 형식에서 영감을 길어왔다. 피사체가 유명인이든 무명의 촌부든 잠깐 방심하고 가면을 벗는 순간을 집요하게 기다리는 걸로 유명한 작가 육명심이기에 이 장승과 수수께끼 같은 검은 형태에서 어떤 얼굴을 보았을까 궁금해진다. 권진규의 가면은 마치 보아서는 안 될 어떤 것을 보았기에 초월적인 힘에 의해 굳어버린 것 같은 표정이다. 의도적인 서툰 묘사에 힘입어 오히려 더욱더 원시적이고 주술적인 힘이 드러난다. 비록 제목은 '가면'이지만 이를 그저 가짜 얼굴이라고만 할 수 있을까? 도자로 빚은 자소상 위에 성속을 넘나드는 인간군상을 그려 넣고 있는 석창원의 〈자화상〉이나 여러 겹의 피부를 벗겨내도 여전히 정체불명의 인물을 그린 김정욱의 〈무제〉(2008) 역시 가면에 대한 지극히 개인적인 명상을 그려내고 있다. 남관과 황주리, 그리고

이홍덕의 그림들은 모두 가면을 쓴 인간 군상을 표현하고 있다. 남관의 <구각(舊殼)된 상(像)>(1988)은 어린이들이 즐겨 하는 긁어내기 기법으로 표현한 천진난만한 얼굴의 집합이다. 제목 속 '구각(舊殼)'이란 단어는 '낡은 껍질'이라는 의미로 이 얼굴들이 일종의 벗어버린 가면임을 암시한다. 황주리의 <가면무도회>(1988)는 캔버스에 한지를 붙인 후 그 각각의 한지 위에 아크릴 물감을 사용하여 단숨에 그려낸 여러 가면의 모습을 나열하고 있다. 훗날 흑·화색으로 이루어지는 연작의 출발점이 되는 작품이다. 이홍덕의 <붓다, 예수 서울에 입성하시다>(1998)는 각종 짐승의 발을 쓴 인간들의 모습과 다양한 인간 군상들이 화면 뒤쪽, 서울로 입성하는 예수와 부처의 환영인파에 떠밀려 나오는 모습을 나타낸다.

3-2. 이종교배

진짜와 가짜 얼굴이 공존한다는 점에서 가면은 본질적으로 이종교배의 속성을 가진다. 그러므로 이런 속성에 주목한 현대미술 작가가 유난히 많은 것이 전혀 이상하지 않다. <슈퍼 히어로즈_몬스터 마스크>(2009)에서 작가 김기라는 더욱 강력한 슈퍼 히어로를 만들기 위해 동양과 서양, 과거와 현재를 가리지 않고 영웅 가면의 이미지를 찾아서 이들을 서로 융합하는 실험을 한다. 아이러니하게도 결과적으로 얻은 마스크는 정체를 알 수 없는 괴물처럼 보인다. <아토마우스>(1993) 역시 또 다른 이종교배 실험의 결과물이다. '아톰'과 '미키 마우스'를 결합한 <아토마우스>를 통해 이동기 역시 동양과 서양, 상업예술과 고급예술이 혼재하는 독특한 가면을 창조하여 자신의 아바타로 삼았다. 미키 마우스는 김나영과 그레고리 마스(Gregory Maass)의 작품 <신경쇠약 미키 마우스>(2007)에서 다시 소재로 채택됐다. 개와 닭을 융합시키려는 미친 과학자와 미키 마우스가 벌이는 소동을 그린 디즈니 원작을 이들은 미키 마우스 자신이 신경쇠약에 걸려 폭주하는 상황으로 바꾸어 설정했다. 평생을 '동심'이라는 가면을 쓰고 아이들의 친구로 살아온 미키 마우스가 결국은 폭발해 버린다는 설정은 흥미롭다.

오를랑(ORLAN)은 아예 자신의 신체를 이종교배 실험대 위에 올려놓는다. <자기교배>(1999) 연작은 특정 지역 및 시대의 '미의 기준'과 자기 얼굴을 디지털적으로 혼합함으로써 아름다움을 강요하는 사회적 억압을 역설적으로 조롱한다. 한효석의 인상적인 초상화들 역시 역사적으로 전개된 미(美)와 추(醜)에 대한 관념에 질문을 던진다. 개인의 정체성처럼 해석되는 얼굴의 표피 한 꺼풀을 벗겨내면 사회 곳곳에 만연하는 편견과

배제는 무의미해진다고 작가는 말하고 있는 듯하다. 신학철의 <변신 3>
(1980)은 잡지에서 오려낸 상품 이미지로 인물의 몽타주를 구성한 작품이다.
이 우스꽝스러운 이미지는 물질문명에 휘둘리며 비명을 지르는 현대인의
가면 같은, 혹은 그래서 어쩌면 더욱 진짜일 수도 있는 얼굴이다. 마지막으로
윌리엄 켄트리지(William Kentridge)의 <코1(가위)>(2007)는 니콜라이
고골(Nikolai Gogol)의 소설 「코」(1837)에 기초하고 있다. 어느 날 코가
없어진 한 남자가 도시 이곳저곳을 헤매다 마침내 코를 만나지만 더 높은
지위에 올라간 코는 그를 무시한다는 내용이다. 마치 사람처럼 가위를 다리
삼아 다소 거만한 자세로 우뚝 서 있는 이 조각은 이종교배의 실험이 결국
성공할 수 없음을 말하고 있는 듯하다.

3-3. 그림자

실체를 반영하는 동시에 왜곡한다는 점에서 그림자 역시 또 다른
가면이다. 전시실 가운데에서 빛나고 있는 김희원의 <누군가의 샹들리에
04>(2021)는 분명 실체인 샹들리에를 찍은 허상 즉 그림자에 불과하다.
그러나 실체가 가진 화려한 장식성, 조명으로서의 기능성, 촛불이 흔들리고
타 버리는 시간성을 모두 갖춘 그림자라면 그 둘의 경계가 모호해지기
시작한다. 피터팬의 그림자처럼 주인에게서 떨어져 나와 신나게 오줌을 쏘아
올리는 곽남신의 <멀리누기>(2002) 역시 그림자의 양면적 특성을 보여준다.
실체와 어떻게든 연결되어 있지만 동시에 독립적이기도 한 이 그림자는 나를
대변하는 가면, 즉 아바타와 같은 존재다. 곽남신의 그림자는 크리스티앙
볼탕스키(Christian Boltanski)와 우주+림희영의 작업에서 다시 강조된다.
천진난만한 아동극을 연상시키는 볼탕스키의 <그림자 연극>(1986)은
실체보다 훨씬 과장된 그림자에 매번 놀라는 현대인의 왜소한 모습을
비추고 있는 듯하다. 기계가 악몽을 대신 꿔주고, 오늘 일어난 나쁜 일을
없애준다면 어떨까 하는 상상에서 비롯된 우주+림희영의 <춤추는 가면_
어둠 먹는 기계>(2011) 역시 그림자의 흐릿한 이미지 속으로 관객의 상상을
초대하는 작품이다. 김영균의 <브레스 #2>(2018)는 제목이 의미하듯 가면을
바꿔 쓰면서 변화하려는 노력은 결국 낯선 세상에 적응하여 살아있고자
하는 절실한 몸부림이다. 그래서 플라스틱 호스를 부는 날카로운 소리가 곧
구조신호처럼 느껴진다.

'Seeing is believing'이라는 격언을 뒤집어 놓은 천경우의 <믿는
것이 보는 것이다 #7-1, #7-2, #7-3>(2006-2007/2012)는 시각 장애가 있는
이들을 초대한 일종의 퍼포먼스다. 다른 이들에게 자신이 어떻게 보인다고

믿는지를 묻고 답하는 30~40분 동안 카메라는 모델을 계속해서 추적한다. 결과적으로 남은 흐릿한 이미지는 그림자일까, 혹은 오히려 본의 아니게 드러난 실체일까? 니키 드 생팔(Niki de Saint Phalle)의 '나나' 역시 작가의 또 다른 자아가 투사된 아바타라는 측면에서 일종의 그림자라고 할 수 있다. 어색하고 불균형한 자세, 날씬한 금발 미인이 아닌 뚱뚱한 흑인의 몸매, 싸구려 원색 페인트로 칠해진 나나는 오를랑과 마찬가지로 미의 기준을 강요하는 사회적 시선에 강력히 대항한다.

조덕현이 만들어낸 그림자는 더 직설적이다. 그는 모핑 기법을 이용하여 삼대에 걸친 직계가족의 얼굴을 합성한 후 여러 겹의 비단에 인쇄하여 겹쳐 놓았다. 이렇게 만들어진 얼굴은 각 집안의 표준적인 이미지이자 고유의 개성이 사라지고 가족이라는 집단을 대표하는 가면 같기도 하다. 독특하게 화물용 엘리베이터 속에 설치된 양정욱의 ‹서서 일하는 사람들 #11›(2015) 역시 형태가 분명하지 않은 그림자와 같다. 이 흐릿함은 노동자의 불안정한 현실과 맞물려 오히려 우리의 공간을 더욱 증폭시킨다. ‹여우털 군단›(2008)에서 난다는 '모던 걸'로 변신한 후 무한 증식하여 군무를 추고 있다. 그림자의 수가 늘어갈수록 그들이 품은 욕망과 쾌락 역시 커지는 자본주의의 속내를 드러내는 것 같다.

3-4. 저항의 가면

정치적 시위 현장에 가면이 등장하는 것은 이제는 익숙한 풍경이다. 강자의 폭력적인 시선으로부터 약자를 보호하는 수단인 가면은 자연히 저항의 아이콘이 되기도 한다. 자크 블라스(Zach Blas)의 ‹얼굴 무기화 세트›(2012-2014)는 사회적 소수자 커뮤니티와의 워크숍을 통해 안면인식 기술로 탐지할 수 없는 네 개의 무정형 가면을 만드는 것으로 약자들에게 저항의 '무기'를 제공한다. 이용백의 ‹엔젤 솔저›(2005)는 또 다른 전쟁을 감행한다. 만약 꽃으로 가득 찬 세상이라면 군인들은 어떤 모습일까라는 엉뚱한 상상에서 시작된 영상에서 꽃무늬 위장복을 입은 군인들이 극도로 천천히 전진하고 있다. 과연 이 전선의 맞은편에는 어떤 적들이 있는 걸까? 박영숙의 ‹헤이리 여신 우마드-풍요의 여신, 분노의 여신, 사랑의 여신, 죽음의 여신›(2004)에서 '우마드(WOMAD)'는 여성(woman)과 유목 (nomad)을 결합한 조어로서, 본인의 의지와 상관없이 결혼을 통해 유목의 삶을 강요받는 여성들을 상징하는 여신들의 이름이다.

때로는 흉내 내기가 저항의 수단이 되기도 한다. 이 전략은 흉내를 통해 가면을 쓰고 그 가면을 통해 다시 소통을 추구한다는 점에서

이율배반적이기도 하다. 조습의 <문지 마> 연작(2005) 중 <물고문>(2005/
2007)과 <임춘애>(2005/2007)는 1980년대 주요한 정치적, 사회적
사건을 흉내 낸다. 이들의 이미지는 공동체의 기억을 통해 각인된 일종의
가면이라는 점에서 공통점이 있다. 후지이 히카루(Fujii Hikaru)의 <일본인
연기하기>(2017)는 워크숍에 참여한 일본인들에게 기록을 바탕으로
제국주의 시기 일본인을 연기해 달라고 요청한 내용이다. 결국 과거의 관념과
행동양식이 현대에도 어떤 모습으로든 존재하고 있음이 드러난다. 다소 결은
다르지만, 김영진의 <몽타주—아름다운 사건>(1991/2019) 역시 제국주의의
기억에 대한 개인적인 해석을 다룬다. 우연히 발견한 두개골 모형에서
상상하게 된 죽음으로부터 인간을 재단하고자 했던 우생학의 시도까지
작가의 관찰은 이어진다. 니키 리의 <프로젝트> 연작 역시 모방 전략을
취한다. <펑크 프로젝트 1, 2, 3, 5, 6, 7>(1997)는 작가가 직접 분장한 후 소위
'펑크족'이라 불리는 집단 속으로 스며들어 간 후 그들의 문화와 동화된 자기
모습을 스냅 사진으로 기록한 것이다. 사진 속의 펑크족 인물들 역시 작가를
자신들의 일원으로 생각하는 듯 자연스러운 포즈를 취하고 있다.

　　곽덕준의 <클린턴 과—I>(1999)은 가면과 흉내를 통해 사회가
통념적으로 바라보는 권력의 허구성을 폭로한다. 미국의 대통령과 자신을
동등하게 바라보는 시선은 그 자체로 사회적 관념에 대한 저항일 수 있다.
이형구는 곽덕준과는 또 다른 방식으로 이미지에 저항한다. 미국 유학
시절 서양인에 비해 왜소한 체형을 보완할 독특한 장치를 제작함으로써
약자가 겪는 소외감과 이질감을 역설적으로 표현했다. 안창홍, 성능경 역시
얼굴이라는 사회적 기표를 변형하는 방식으로 자신의 이야기에 설득력을
더한다. 안창홍의 <가족사진>(1982)에서 가면으로 표정을 가린 가족에게는
죽음과 부재의 불길함이 떠돈다. 아직 광주의 기억이 생생했던 1980년대
초라는 배경을 생각해 보면 가혹한 시대에 기어이 살아남은 우리에게
역사가 건네는 준엄한 시선 같기도 하다. 신문에 실린 얼굴들을 무작위로
근접 촬영한 후 노란색 띠로 눈을 가린 성능경의 <특정인과 관련 없음 1>
(1997)에서도 또 다른 부재의 느낌을 찾아볼 수 있다. 범죄 용의자의 눈을
검은 띠로 가리던 1970년대의 언론 관행에 빗대어 작가는 사회적 판단의
허구성에 의문을 던진다. 검열과 통제가 극한에 이르렀던 말기 유신
체제라는 시대적 상황을 고려해 볼 때, 마치 안창홍의 <가족사진>처럼 이
사진 속 인물들 역시 역사적으로 무시되고 익명화되어 버린 많은 개인들을
상징하는 듯 보이기도 한다.

4. 무도회를 나서며

《가면무도회》에 전시된 41점의 작품들은 이 수많은 생각의
바다에서 건져 올린 약간의 견본들이다. '가면'이라는 얼핏 협소해 보이는
주제에도 불구하고 국립현대미술관의 소장품에서 출품작을 선정하는데
그다지 어려움이 없었다는 점이 현대미술 자체가 이미지 즉, 가면을 둘러싼
담론이라는 기획자의 생각을 간접적으로 증명하는 듯했다. 실제로 훨씬 더
많은 가면이 다음 무도회를 기다리며 여전히 수장고에서 쉬고 있다.

이번 무도회에 초대받은 작품들은 각자 개성을 뽐내며 마음 맞는
이들끼리 군데군데 모여서 담소도 나누고 다른 이들을 곁눈질하기도 하면서
즐거운 한때를 보내고 있다. 관객들도 각각의 면모를 관찰하면서 혹은 여러
가면 간의 은밀한 관계를 추리하면서 그들의 시간에 잠시 동참할 수 있다면
매우 흥미로운 경험이 되었을 것이다. 더 나아가 전시실 초입에 선보인
대중문화 속의 익숙한 가면들과 현대미술이 다루는 가면들 사이 유사점과
차이점을 생각해 보는 것도 의미 있는 선택이다. 결국 이 현대미술의
가면들은 우리들 자신이 쓰고 있는 가면에 관하여 스스로 되돌아보기를
바라고 있지 않을까 생각해 본다. 기획자로서는 이 무도회를 퇴장하는
이들이 새롭게 가지게 된 가면에 대한 명상이 자못 궁금하다. 어쩌면
갑작스럽게 마스크가 일상이 되어버린 지금이야말로 이 명상에 최적의
시간일 수도 있지 않을까.

Masquerade

Lim Dae-geun
Curator, National Museum of Modern and
Contemporary Art, Korea

> I greet you, sisters! Though today,
> And the whole of yesterday,
> You enjoyed the masquerade,
> I know all will be displayed:
> In the morning you'll unveil.
>> A line from "Hope" in Johann
>> Wolfgang von Goethe's *Faust*

1. The Inside and Outside of Masks

Masks are ambivalent. They enable us to distance ourselves from the gazes of others, while also allowing us to draw nearer to those same gazes by providing a curtain for us to hide behind. Masks are images. They are thoroughly staged fakes. Thus, they always attract curiosity as to what may be hidden underneath; the bare faces that can be found there would not be of any interest if they were not hidden. Indeed, they are what we seek to reveal due to their concealment.

Masks represent a form of culture. They signify a stylish curtain decorated by conventions and prejudices. What stands just beyond the curtain, however, is a naked animal with two legs: a primate with startled eyes, looking for food, mating, raising his young, and hiding from predators.

Masks exist in the animal world, too. They function as camouflage that is used by the weak to protect themselves from predators. By contrast, masks can also be used by predators to disguise themselves from their prey. There are other times when animals use masks to augment their appearance and attract partners during mating season. However, what lies beyond the masks worn by humans is not nature, but culture. Culture is a new type of predator, one which is often far more violent and ruthlessly brutal than any part of nature. Humans wear masks either to protect themselves from the relentless gaze of culture as a predator, or else to express a covert resistance against it. As such, masks exist at the point where one's intimate self publicly encounters others, culture, and norms. It can thus be said that the inside and outside of masks define the whole world in which we reside.

In this sense, it is not at all surprising that many contemporary artists adopt masks as subject matter. After all, it is rare to find such an object that encompasses all the contradictions, absurdities, tensions, and temptations of the human world—in short, the primary concerns of contemporary artists. Some artists reflect on how to take masks off, others think about the ways in which masks are used, and some even wonder how and why we wear masks in the first place. There are also those artists that make us aware of masks' existence by putting even more masks on our faces. And some artists bluntly confront us with our own naked faces, which are revealed at the moment that our masks come off. The artist's gaze constantly returns to the theme of masks, since contemporary art itself may ultimately be considered as a reflection on these masks, regardless of artistic subjects or methods.

2. Contemporary Art and Images

Countless invisible things have been devised and developed as a result of the anthropocentric self-conception that humans are different than animals, as well as the emergence of abstract cognition in contrast to instinctive behavior: this includes almost everything that we are familiar with at present, such as concepts, conventions, morals, discourses, histories, ethnic identities, and nations. These things can neither be touched nor seen, which makes it impossible for me to teach them to the house cat that I live with or convince her about their existence. Images are what the human brain relies upon to undertake the difficult task of representing invisible things. For example, consider the concept of "filial piety." Can you imagine this concept? As soon as you pause to think about it, you may immediately picture a devoted daughter sacrificing herself for her family, or your neighbor's son who is praised in your neighborhood for his filial piety. How about "Republic of Korea," as a pure concept? This phrase calls to mind a series of images that may include the country's national flag or the crater lake of Baekdusan Mountain on the border between mainland China and the Korean Peninsula, or perhaps scenes from the film *Ode to My Father* that represents Korea's turbulent modern history.

Images ought to be fragile since they lack inherent substance; however, as we all know, the opposite is more often the case. Bolstered by the unique thought process of human imagination, we give tremendous power to these images, so much so that they may even exceed our expectations. Take, for instance, the countless examples of people who willingly sacrifice their lives for the sake of morality, patriotism, or religious beliefs. Because images exist without substance, they are more readily reproduced and shared to an infinite degree. Moreover, due to

their collective nature, they may be even more disruptive. At this point, I can only imagine the type of look my cat would give me if I were to tell her that the story of Romeo and Juliet and its ideal of love is much more precious than the cat food I would subsequently give her—if, of course, she were able to converse with humans. (Here, I would like to point out that my attitude toward cats is based on images created by humans like Natsume Sōseki.)

It is very hard to resist the power that ironically arises from the absence of substance. In this regard, the war front has already become too expansive, making it difficult to even comprehend the overall situation. Yet, there are people who remain in the trenches of this chaotic war, among whom are contemporary artists. Since Marcel Duchamp overturned the "pretentious" image of art by placing a urinal in an exhibition space, the battle between contemporary art and images has fiercely unfolded throughout the twentieth and twenty-first centuries. Whether artists drip paint on canvases, reproduce Coke bottles in print, stack television monitors, or perform naked in front of audiences, there are always certain images that dominate and confine us beyond what can be described as avant-garde, running the gamut from grand images of nations, religions, and ideologies to intimate images of personal memories and wounds. Whether or not contemporary artists are aware of this issue, it would not be an exaggeration to generalize their ultimate interest as being the destruction of all images, including the image of art itself.

However, the most effective weapon wielded by artists is this very use of images. Thus, their prospects of victory in this paradoxical battle seem hopelessly distant. This is why even if artists succeed in carving tiny chips out of the solid walls of images, they would soon themselves embody yet another image: a target of resistance by the next generation's artists. In the end, the history of contemporary art is nothing more than the endless construction of a fortress of images, each of which represents a form of subversion, all stacked on top of each other. But then again, who knows? One day, even those of us who remain safe in the rear, far from the ongoing battle, may be inspired by these artists' struggles and take up arms ourselves in order to fight in our own ways. The hidden truth behind images would then be revealed to the world at last. At this moment, an image of "emancipation"—the very image that concludes *The Matrix* film series—comes to my mind. Even in those films, such an image also sowed the seeds of doubt that the belief in some other substance might be just another image.

3. Invitation to the Masquerade
In *Masquerade*, masks operate as another name for images that

conceal an underlying substance. If we consider contemporary art as a constellation of images about images, we could also say that it presents masks about masks. Once we remove the masks, would their hidden substance be disclosed? Or would it only be revealed after placing countless masks on top? Has someone put masks on us, or have we willingly put them on ourselves? We may think that masks conceal substance, but would we even be able to see these masks? Are we not blind to what can be truly seen, just like the naked king who believed he was wearing invisible clothes and the crowd who worshiped him, themselves blinded by invisible masks? As an exhibition, *Masquerade* is curated with the hope that the viewers would confront these questions as they leave the gallery. Along the wall that leads to the exhibition hall, a video anthology and various visual designs greet visitors with images of masks from popular culture, especially popular movies. The images are presented as a means of encouraging viewers to compare the masks found in contemporary artworks and the ones that they may already be familiar with.

Circular Gallery 1 presents a total of forty-one artworks: thirty-four works from the MMCA collection; three from the MMCA Art Bank; four works from private collections. Given the festive nature of a masquerade and the circular layout of the gallery space, the exhibition design does not adhere to specific types of artworks or themes. Nevertheless, artworks are arranged in groups that are loosely organized according to similar themes or attitudes. This resembles the behavior that might be observed in a ballroom, where masquerading people with similar interests might naturally gather and talk to each other.

3–1. Mask vs. Naked Face

KIM Young Kyun's *Vishnoir* (2011) greets exhibition visitors with a ball-jointed doll wearing a mask in which a child's face can be seen entangled among skulls. This work suggests a message of "Memento mori," a warning to those entering the masquerade that the festivities will inevitably come to an end and they will have to take off their masks.

After stepping through a red curtain to enter the exhibition, visitors are invited to encounter two photos which are *Jeju Island* (1982/2017) and *Jangseung (Totem Poles) Series-Samil-dong, Yeosu, Jeollanam-do* (1987/2017) by YOOK Myeongshim, along with KWON Jinkyu's *Mask* (1960s) and SEOK Changwon's *Self-Portrait* (2006–2013) series. These works draw inspiration from the imagery and shapes typically found in traditional masks. YOOK Myeongshim is known for patiently awaiting the moment in which his subjects are caught

off-guard, regardless of whether they are well-known figures or anonymous individuals. Thus, one cannot help but wonder at what he observed in the mysterious faces and totem poles that populate his photos. The mask in KWON Jinkyu's work reveals a more primitive and magical power. Its expression appears frozen, as if by a transcendental power after the face witnessed something that it should not have seen. The artist's intentionally inelegant sculptural details strengthen such an impression. Although the work is titled *Mask*, might we also consider it a false face? Other works constitute very personal meditations on masks. While SEOK Changwon's *Self-Portrait* depicts different human images on ceramic faces, KIM Jungwook's *Untitled* (2008) portrays a person that is perpetually unidentifiable, due to being obscured beneath several layers of peeling skin. Paintings by NAM Kwan, HWANG Julie, and LEE Heungduk depict crowds of masked people. NAM Kwan's *Withered Figures* (1988) is a collection of innocent faces expressed by the scratching technique often used by children. Written in traditional Chinese characters, the work's title includes *Gugak* (舊殼), which literally means "old shells." This suggests that the faces of different people in the painting are actually masks that have been removed. HWANG Julie's *Masquerade* (1988) presents an array of masks in different shapes, which are visualized using acrylic paint by attaching *hanji* paper to the canvas. This work serves as a starting point for a series of other grayscale works that depict various human figures. In LEE Heungduk's *Buddha and Jesus Enter the City* (1998), groups of people wearing masks of various animals are pushed back by crowds who welcome Jesus and the Buddha as they enter the city of Seoul.

3–2. Crossbreeding

Masks are essentially crossbred, due to the fact that they feature both real and fake faces at the same time. Therefore, it is not at all strange that so many contemporary artists focus on the dualistic nature of masks. For example, KIM Kira finds images of heroic masks from different regions and periods that span East and the West as well as past and present through *Super Heroes_Monster Mask* (2009). He then fuses them together, creating reinforced superhero figures; ironically, the resulting masks resemble the faces of mysterious monsters. LEE Dongi's *Atomaus* (1993) is also the product of a crossbreeding experiment: a combination of Atom (also known as Astro Boy) and Mickey Mouse, which results in a unique mask that integrates Eastern and Western

sensibilities and merges commercial art and fine art. Mickey Mouse is also appropriated in *Psychotic Mickey Mouse* (2007), an installation by Nayoungim & Gregory Maass. In a departure from the original Disney animation in which a mad scientist tries to fuse a dog with a chicken, Nayoungim & Gregory Maass instead stage a situation where Mickey Mouse experiences a nervous breakdown. Here, Mickey Mouse and the childhood innocence that he symbolizes leads to madness.

In *Self-Hybridization* (1999) series, ORLAN takes the idea of crossbreeding one step further by experimenting on her own body. Her series digitally mixes her own face with "standards of beauty" that pertain to different regions and eras, incisively mocking the prevalence of social pressure to emulate such beauty standards. Meanwhile, HAN Hyoseok's striking portraits of faces also question historical concepts of beauty and ugliness by showing faces whose skin has been peeled off. These works suggest that society's rampant prejudice and exclusion become insignificant when just a layer of skin, which is often construed as representing identity, is peeled away from one's face. SHIN Hakchul's *Transformation 3* (1980) visualizes a montage of a person using collaged images of products that have been cut out from various magazines. While the resulting composite image looks ridiculous, it may actually epitomize the image of masks worn by the artist's contemporaries who, in a state of panic, become engulfed by civilization's materialism. In this sense, the mask in SHIN's work begins to appear more real than anything else. Finally, William KENTRIDGE's *Nose1 (Scissors)* (2007) depicts the eponymous figure of Nikolai Gogol's short novel *The Nose* (1837), which centers around a man who accidentally loses his nose. He wanders around the city looking for his nose, and when he finally encounters it, the nose has assumed a higher position than the man and refuses to talk to him. In KENTRIDGE's work, the nose stands tall in a somewhat arrogant posture, with scissors serving as its legs. The image conveys a message that crossbreeding experiments cannot succeed in the end.

3–3. Shadows

Shadows simultaneously reflect and distort reality. In this sense, shadows are also masks. Glowing in the middle of the exhibition space, KIM Heewon's *Someone's Chandelier 04* stands as a mere illusion of a real chandelier. However, if one considers it as a shadow that is equipped with elaborate decorativeness of the real chandelier and the flow of time in which candles are swayed and burnt, the line between the real and the illusion becomes blurry. KWAK Namsin's *Pissing Farthest* (2002) which breaks away from the body like Peter Pan's shadow and pisses out

on the air symbolically shows these two characteristics of the shadow. As such, the shadow is both connected to and independent from reality, existing as a kind of mask or an avatar that represents oneself. The shadow in KWAK Namsin's work is reiterated in the works of Christian BOLTANSKI and Ujoo+LimHeeYoung. BOLTANSKI's *Theatre of Shadows (Théâtre d'Ombres)* (1986) is reminiscent of a shadow play for innocent children and reflects the diminutive look of the artist's contemporaries who are always astonished by such exaggerated shadows. Ujoo+LimHeeYoung's *Temptation of the Dancing Mask – Dark Eating Machine* (2011) is based on the simple idea of a machine capable of enduring nightmares on behalf of humans and eradicating unpleasant occurrences that we experience during our waking hours. The work invites viewers to use their imaginations in visualizing the blurry images of its shadows. KIM Young Kyun's *Breath #2* (2018) reveals that our efforts to constantly change ourselves by switching masks is ultimately a desperate struggle to adapt to and survive within the unfamiliar world around us. Thus, the sharp sound made by blowing through a plastic hose in this work feels like a rescue signal.

CHUN Kyungwoo's *Believing is Seeing #7–1, #7–2, #7–3* (2006–2007/2012) flips the aphorism of "seeing is believing" through a video performance whose participants have visual impairments. For thirty to forty minutes, the camera constantly tracks its subject, who answers questions about what she looks like to others. Could the blurry image produced through this process be considered a shadow of the subject, or rather its substance that is unintentionally disclosed? In this sense, it is also possible to consider Niki de SAINT PHALLE's "Nana" as a kind of shadow since it operates as an avatar onto which the artist's other self is projected. Depicted using cheap paints in primary colors, Nana stands in an awkward and unbalanced posture, her portly black body differentiating itself from the artist's slender white body and blonde hair. Similar to ORLAN's work, this piece stands in stark opposition to the social gazes that impose standards of beauty.

Meanwhile, CHO Duckhyun creates shadows that are more direct and overt in nature. His prints on silk depict the faces of a direct line of family members whose visages are superimposed, with the resulting image encapsulating the normalized images of a single bloodline. At the same time, however, these pluralistic faces can also be interpreted as masks that erase the individuality of different people. YANG Jung Uk's *Standing Workers No.11* (2015) also resembles shadow with an indeterminate shape and is uniquely installed inside a freight elevator. The blurriness of the work, coupled with the reality of workers' unstable working conditions, amplifies viewers' feelings of

sympathy. Then comes Nanda's *Crazy Fox Corps* (2008), in which the artist turns into a "modern girl" from the early 20th century Korea as she dances in groups while infinitely multiplying herself. Along with this increasing number of shadows, their corresponding desires and pleasures reveal the hidden essence of capitalism.

3–4. Masks of Resistance

It has now become commonplace for people taking part in political protests to wear masks. After all, masks are a tool for protecting the weak from the violent gaze of the strong, and thus naturally become icons of resistance. Zach BLAS' *Facial Weaponization Suite* (2012–2014) provides social minorities with just such a "weapon" of resistance: four amorphous masks that cannot be detected by facial recognition technology, which he developed through workshops with minority communities. On the other hand, LEE Yongbaek's *Angel Soldier* (2005) launches another war, based on a wild imagination that visualizes soldiers amid a world full of flowers. In the video, soldiers wearing floral camouflage uniforms advance across the screen at an extremely slow pace. Who are the enemies facing these soldiers on the opposing front? PARK Young-sook uses the word "WOMAD" as the title of her series *WOMAD-Goddess of Mother Earth and Fertility, Goddess of Indignation, Goddess of Love and Passion, Goddess of Salvation and Death* (2004). A portmanteau of "woman" and "nomad," the term refers to women who are forced to live nomadic lives, regardless of their own will, after marriage.

Sometimes, mimicry also functions as a means of resistance. In a way, the strategy of mimicry is self-contradictory, particularly if we think of what happens when we put on a mask to resemble another entity yet continue to communicate through this facade. JO Seub's *Water Torture* (2005/2007) and *Lim Chun-ae* (2005/2007) mimic the major political and social events that defined South Korea in the 1980s. These works are similar in their proposition that certain kinds of masks become imprinted upon collective memories. In FUJII Hikaru's *Playing Japanese* (2017), the artist documents participants of a workshop in which Japanese citizens were asked to portray Japanese people from the imperial period, based on historical records. The work reveals that the ideas and the behavior of the past may persist into the present, albeit in different forms. KIM Youngjin's *Montage-Beautiful Event* (1991/2019) also investigates the memories of imperialism by taking a slightly different approach than that of FUJII Hikaru's work and delving into more personal memories. KIM Youngjin's observations begin with an imagined death that arose in his mind after the artist accidentally

discovered a skull replica, eventually developing into a deeper investigation of eugenics. Nikki S. LEE's *Project* series also employs the strategy of mimicry. In *The Punk Project 1, 2, 3, 5, 6, 7* (1997), the artist dressed up as a member of a punk group and assimilated herself into their subculture. In the snapshot photos in which she appears, she looks just as natural as other punk group members, who accept her as one of their own.

KWAK Duckjun's *Clinton Kwak–1* (1999) uses masks and mimicry to expose the fallacy of power in the face of social norms and conventions. In this work, the artist sees himself on equal terms as the President of the United States, a perspective that itself may suggest resistance to socially accepted norms. In *Altering Facial Feature with H–WR* (2007/2009), LEE Hyungkoo resists the notion of images in a slightly different manner than KWAK Duckjun. During his studies in the United States, LEE Hyungkoo devised unique devices to augment his body, which is comparatively smaller than those of Westerners, ironically expressing the isolation and alienation he experienced as a social minority. AHN Changhong and SUNG Neungkyung also use faces as social signs by transforming them in order to make their artistic narratives more persuasive. In AHN Changhong's *Family Photograph* (1982), an ominous sense of death and absence can be felt in the scene of a family whose members hide their faces behind masks. This work was produced in the early 1980s, when the tragic memory of the Gwangju Uprising was still fresh. In this sense, the work may seem like the stern gaze of history cast upon those of us who survived such harsh times. In SUNG Neungkyung's *No Relation to a Particular Person 1* (1997), random figures from newspaper photographs are shown with their eyes covered by yellow tape, generating a different sense of absence. In the 1970s, it was customary to overlay black boxes onto newspaper photographs in order to cover the eyes of people under criminal investigation. Here, the artist appropriates this practice as a method of casting doubt on the veracity of social judgment. Considering that the work was produced in the waning years of a dictatorial regime in which censorship and social control reached peak levels, the anonymous figures in SUNG Neungkyung's work also resemble the historically ignored and anonymized individuals in AHN Changhong's *Family Photograph*.

4. Leaving the Masquerade

The forty-one artworks on display in the exhibition *Masquerade* may be considered a few samples extracted from a sea of countless thoughts. Despite the seemingly specific theme of "masks," there

was not much difficulty involved in identifying artworks from the MMCA collection that responded to such a theme. From a curatorial perspective, this supports the conceptual framework that contemporary art is essentially based on a discourse of images or masks. In fact, there are even more masks quietly waiting in storage for the museum's next masquerade to be held.

The artworks that were fortuitously included in this masquerade show off their uniqueness while gathering together in different corners of the space to chat with each other and gaze at the rest of the artworks on display. If we, as viewers, could join them by observing each mask individually and contemplating their secret interrelationships, the exhibition experience would become much more interesting. Not only that, but it would also be meaningful to reflect on the similarities and differences between the familiar masks of popular culture found at the entrance of the exhibition and those contained within the gallery space. In the end, it may be possible to assume that the masks of these contemporary artworks invite us to reflect on the masks that we ourselves wear. As a curator, I am more than curious to learn about each viewer's personal meditation on masks as they leave the exhibition. It may also be true that the present moment—in which an altogether different type of mask has become a part of our everyday lives— provides us with a renewed opportunity to reflect on the issues of masks and contemporary art.

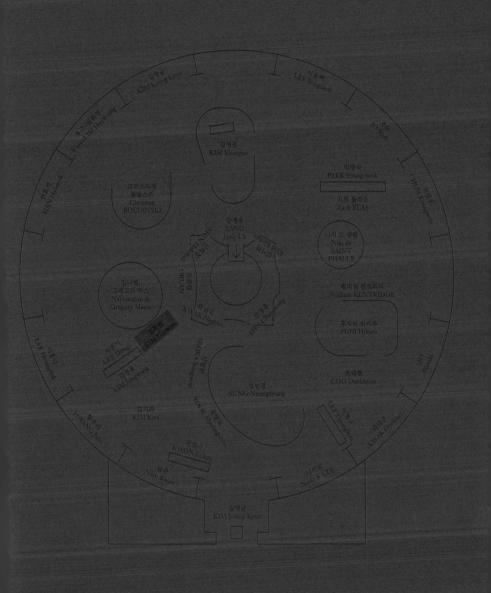

김영균
KIM Young Kyun

이용백
LEE Yongbaek

임희영
Urssu LIM Hee Young

김영진
KIM Youngjin

한효석
HAN Hyos & k

크리스티앙
볼탕스키
Christian
BOLTANSKI

조습
JO Sub

진경우
CHIN Kyungwoo

박영숙
PARK Young-sook

차크 블라스
Zach BLAS

니키 드 생팔
Niki de
SAINT
PHALLE

양정욱
YANG
Jung Uk

김나영,
그레고리 마스
Nayoungim &
Gregory Maass

윌리엄 켄트리지
William KENTRIDGE

후지이 히카루
FUJII Hikaru

이동기
KIM Daesoon

곽남신
KWAK Namsin

민정홍
MIN Chanhong

이흥덕
LEE Heungduk

김정욱
KIM Jungwook

나래
Narae

조덕현
CHO Duckhyun

성능경
SUNG Neungkyung

육명심
YOOK Myoungshim

이형구
LEE Hyunggu

곽덕준
KWAK Duckjun

황주리
HWANG Julie

김기라
KIM Kira

권진규
KWON Jinkyu

남관
Nam Kwan

이우환
Nikki S. LEE

김영균
KIM Young Kyun

국립현대미술관 과천 1원형전시실
《가면무도회》 전시장 지도

27

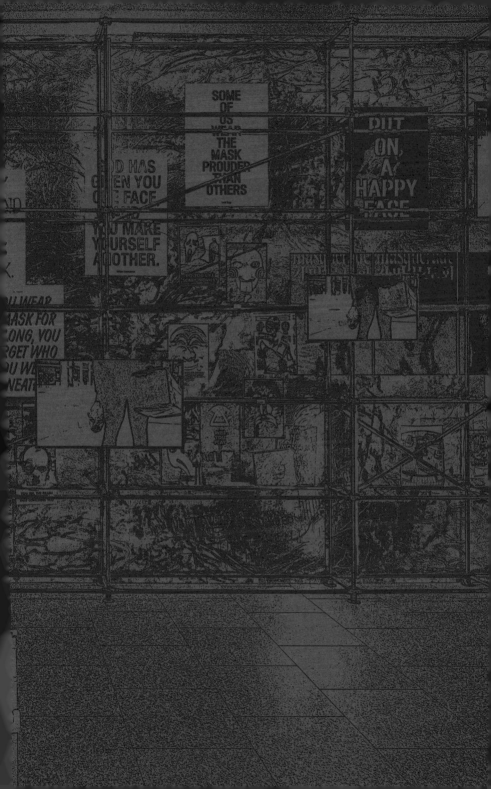

가면 vs. 민낯

Mask vs. Naked Face

권진규
김영균
김정욱
남관
석창원
육명심
이홍덕
황주리

KWON Jinkyu
KIM Young Kyun
KIM Jungwook
NAM Kwan
SEOK Changwon
YOOK Myeongshim
LEE Heungduk
HWANG Julie

김영균의 <비슈누아>는 두 개의 낡은 괘종시계와 금속 다리로 만들어진 좌대와 기괴한 형태의 가면을 쓰고 있는 구체관절 인형으로 이뤄져 있다. 작가는 "흐르는 시간 위에 무상히 앉아 있거나 서 있거나 혹은 떠 있는 존재들"을 염두에 두었다고 한다. '비슈누아'는 힌두교의 비슈누(Vishnu) 신과 검은색을 뜻하는 누아르(Noir)를 합친 조어이다. 창조신의 밝은 에너지와 어두운 그림자를 조합해 놓은 제목은 그 자체로 모순적으로 "떠 있는" 이름이다. 그래서 이 인물이 뜻하는 의미도 명확하지 않다. 인간을 유혹하는 신의 몸짓 같다가도 어린아이와 해골이 엉켜있는 가면처럼 유한성을 숙명처럼 뒤집어쓰고 이제 막 일어서는 인간 같기도 하다.

KIM Young Kyun's *Vishnoir* consists of two old wall clocks, a pedestal with metal legs, and a ball-jointed doll wearing a bizarre mask. The artist says that the work considers "beings that are sitting, standing, or drifting in the flowing time." The title "*Vishnoir*" combines the Hindu god Vishnu and the word Noir, meaning the color black. As a combination of the confident energy of the God of creation and the dark shadow of black color, the title is by itself a "drifting" name. As such, it is also unclear what the bizarre figure in this work indicates. It also seems to be wielding a godly gesture to entice humans. At the same time, it looks just like a human being that is about to stand up with the symbols of finitude—children and skulls—on top of its head.

김영균(1977~)
KIM Young Kyun

비슈누아
Vishnoir

2011

무발포우레탄, 괘종시계, 합판, LED 조명, 금속
Resin, clock, wood, LED lighting, metal

170×50×50cm

작가 소장 Courtesy of the artist

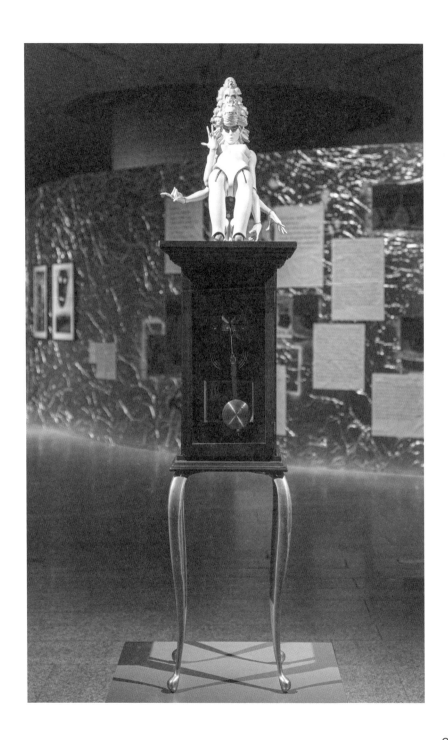

<제주도>는 육명심이 독학으로 공부하던 초기 사진 작업들을 정리한
사진집 「영상사진 1966–1978」(2012)을 펴내면서 마치 이 시기를 회고하는
후기처럼 추가한 작품이다. <인상(印象)> 연작(1960년대)을 포함한 그의
초기 사진들은 대상의 객관적 기록이나 미학적 탐구를 넘어, '인상'을
받은 작가의 내면세계를 드러내는 데에도 관심이 있었음을 알게 해 준다.
<제주도>는 정체가 모호한 이미지를 초기 사진 특유의 강한 흑백 대비와
과감한 화면구성을 통해 포착하고 있다. 가면과 같은 형태는 <장승> 연작
(1982–)과의 연결점을 보여준다.

Jeju Island is a photography work added as a postscript to his book
Image Photography 1966–1978 (2012), an anthology of his early
photography as a self-taught photographer. YOOK's early works show
his interest in revealing the inner world of an artist who felt certain
'impressions' beyond producing objective documentation and aesthetic
investigation. The *Impression Series (1960s)* is one such example of
his interest. In *Jeju Island*, the artist captures an ambiguous image
through the strong contrast in black and white and bold composition,
which uniquely define his early works. The mask-like shape in the
image also shows a connection with another series titled *Jangseung
(Totem Poles)(1982–)*.

육명심(1933~) 제주도
YOOK Myeongshim *Jeju Island*

1982(2017년 인화)

디지털 잉크젯 프린트
Digital inkjet print

76.2×50.7cm

국립현대미술관 소장 MMCA Collection

순수한 한국 토박이들의 얼굴을 찍어 보겠다고 '백민(白民)' 연작(1978-)
을 시작한 지 한참이 지난 시점인 1980년대 중반 지친 작가의 눈에 들어온
것이 장승이었다고 한다. "결국 장승이라는 건 만든 사람이 자기 얼굴을
만든 거구나…. 한국인의 순수한 그 얼굴이다."라고 생각한 작가는 이후 5년
동안 다시 온갖 장승을 찾아 전국 방방곡곡을 누비고 다녔다. 심지어 어떤
곳은 "정이 들어서" 대여섯 번씩 찾아가기도 했다. 육명심이 "머리가 아닌
가슴으로 몸으로 찍은" 장승은 어쩌면 맨얼굴보다도 더 솔직한 우리들의
가면일지도 모르겠다.

YOOK Myeongshim's search for Jangseung totems began a while after
he had started the *Baekmin (Ordinary People) Series* (1978-), which
captured the faces of ordinary people in Korea. He thought, "Jangseung
totems have faces of their creators… And those faces are the innocent
faces of Korean people." For the next five years, he traveled all over the
country in search of all kinds of such totems. He even visited a certain
place more than five times because he had "developed an attachment"
to the place. The Jangseung totems in YOOK Myeongshim's photos
are "captured not through thoughts but through the mind and body."
They might represent the very masks we are wearing, which can be
more candid than our own faces.

육명심(1933~)
YOOK Myeongshim

장승 시리즈—전라남도 여수 삼일동
Jangseung (Totem Poles) Series—Samil-dong, Yeosu, Jeollanam-do

1982(2017년 인화)

디지털 잉크젯 프린트
Digital inkjet print

76.2×50.7cm

국립현대미술관 소장 MMCA Collection

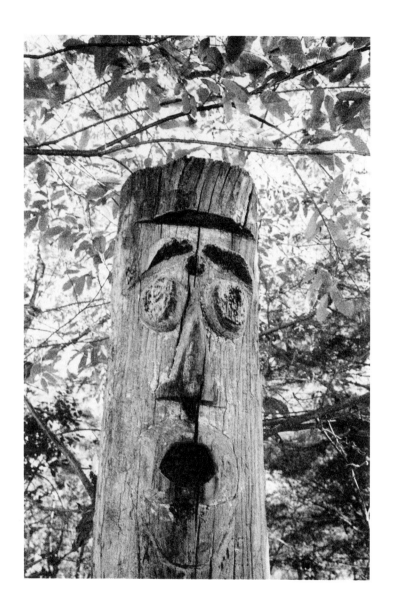

권진규는 전통 공예기법인 건칠(乾漆)을 도입하거나 추상적인 부조 작품들을 제작하는 등 새로운 실험들을 지속적으로 이어 나갔다. 완전 입체인 환조와 평면적인 부조의 중간 형태인 <마스크> 역시 이 실험적인 작업 중 하나다. 일찍부터 스승 시미즈 다카시(Shimizu Takashi)를 통해 알게 된 앙투안 부르델(Antoine Bourdelle) 만년의 부조 작업들과 개인적으로 관심을 가졌던 병산탈의 해학적인 모양을 융합하여 매우 인상적인 가면을 만들어 내었다. 마치 보아서는 안 될 어떤 것을 보았기에 초월적인 힘에 의해 굳어버린 것 같은 표정은 의도적인 서툰 묘사에 힘입어 오히려 더욱더 원시적이고 주술적인 힘을 드러내고 있다.

As a sculptor, KWON Jinkyu ceaselessly took on new experiments even during the period when he was producing bust sculptures. He introduced the traditional dry lacquer technique and created abstract relief works as well. Created as an intermediate form in between a full three-dimensional relief in a round and a flat relief, *Mask* is one of such experimental works. Since the early days of his artistic career, KWON has created impressive masks. They combined the characteristics of late relief works by Antoine Bourdelle, an artist he had come to know through his mentor Shimizu Takashi, and the humorous shapes of Byeongsan Masks that KWON was personally interested in. The look on KWON Jinkyu's *Mask* makes the viewers feel as if it was frozen by a transcendent power for seeing something that should not be seen. It reveals a more primitive and magical power, strengthened by the artist's intentionally inelegant sculptural expression.

권진규(1922~1973)
KWON Jinkyu

마스크
Mask

1960년대

테라코타
Terra-cotta

18×18×11cm

국립현대미술관 소장 MMCA Collection

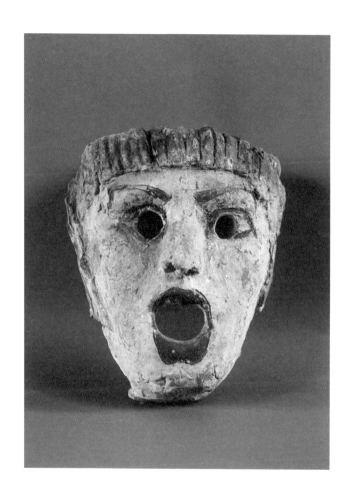

석창원의 <자화상>은 도자로 빚은 얼굴 형상 위에 점묘 방식으로 다양한 형태들이 입혀진 작품이다. 이미지는 대부분 인간의 모습인데, 때로는 십자가에서 내려지는 예수처럼 숭고한 모습이기도 하고, 지옥 같은 불더미 안에서 서로 뒤엉킨 타락한 모습으로 나타나기도 한다. 인간 형상과 함께 자주 등장하는 나비는 장자의 꿈속 나비 이야기와 연결되는데, 네 개의 눈동자와 함께 현실과 초현실을 넘나드는 인간의 내면을 상징한다.

SEOK Changwon's *Self-Portrait* is a ceramic figure of a face on which different shapes are depicted in a pointillist style. Most of them appear as humans, often seeming to be sublime like Jesus descending from the cross or degenerate as they are entangled in the hellish fire. Frequently appearing along with the human figures is a butterfly, which can be associated with Chuang-tzu's story of being a butterfly in his dream. In *Self-Portrait*, the butterfly symbolizes the inner world reverberating between reality and the surreal, along with the presentation of four eyes on the ceramic faces.

석창원(1966~)
SEOK Changwon

자화상
Self-Portrait

2006–2013

조합토에 채색, 유약
Painting on mixed clay, glaze

32×20.5×7, 33.5×21×7.5, 36.5×1×8.5, 35×21×9, 35.5×22×8.5cm

국립현대미술관 소장 MMCA Collection

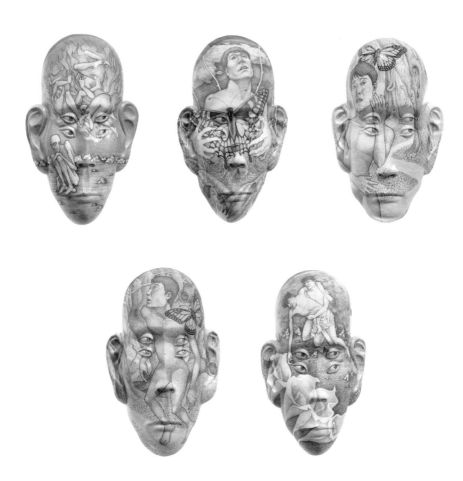

김정욱의 <무제>는 한 인물의 얼굴을 클로즈업하여 묘사하고 있다. 여성인지 남성인지 모호한 인물이 있고 그 얼굴의 피부는 마치 허물처럼 벗겨지면서 새로운 얼굴이 드러나고 있는 듯 보인다. 드러나는 인물의 큰 눈은 마치 심연처럼 깊이를 재기 어렵다. 무언가 강렬한 욕망을 감추고 있는 듯 사악하게 보이다가도 다시 눈자위에만 집중해서 보면 한없이 선량하게도 보인다. 과연 이 인물에게 가면은 어디까지인가. 결국에는 그 가면을 벗어버릴 가능성이라도 있는 것일까?

KIM Jungwook's *Untitled* depicts a person's face in a close-up. It is ambiguous whether the person is a woman or a man, and the skin seems to be peeling off to reveal a new face. It is difficult to assume the depth of the large eyes on the new face, as if looking into a deep abyss. They at once look evil, as if they are hiding a strong desire for something. Yet, they also look absolutely innocent if one solely focuses on their eyes. For this person, what is the limit of his or her mask? Is there any possibility that he or she will eventually take the mask off?

김정욱(1970~)
KIM Jungwook

무제
Untitled

2008

한지에 수묵채색
Ink and color on paper

114.5×129cm

국립현대미술관 소장 MMCA Collection

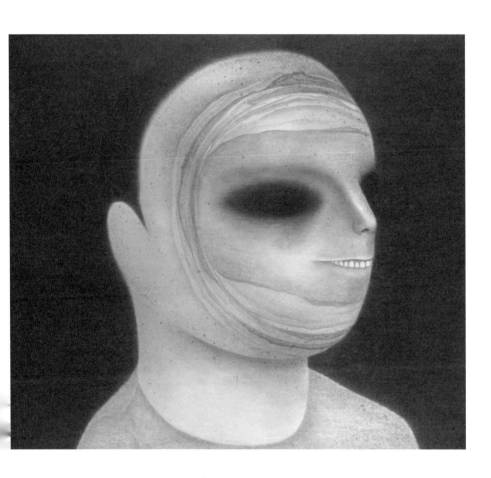

1980년대에 접어들어 남관은 1960-1970년대의 추상화와는 다소 다른 경향의 작품을 제작하기 시작했다. 이 시기에는 인물들이 구체적인 형상을 갖추었으며 순진무구한 어린아이와 같은 동화적인 세계가 표현되었다. ‹구각 (舊殼)된 상(像)›은 다채로운 원색 위에 검은색을 칠한 뒤 다시 긁어내는 기법으로 다양한 인물상을 표현한 것이다. 이 작품은 작가가 타계하기 2년 전에 제작한 것으로서 노대가의 유희적인 자유로움을 전해준다. 제목 속 ‘구각(舊殼)’이라는 단어는 ‘낡은 껍질’이라는 의미로 이 얼굴들이 일종의 벗어버린 가면임을 암시한다.

In the 1960s and 1970s, NAM Kwan mostly focused on abstract paintings. In the 1980s, however, he started producing works in a slightly different direction. During this period, the figures in his paintings took on more concrete shapes. He also depicted an innocent and childlike world of fairy tales. *Withered Figures* is a painting depicting a variety of figures by applying black paint on top of diverse primary colors and scraping them off. The work was produced two years before the artist's death, and it shows the artist's playful freedom, which he regained toward the end of his life. 'Gugak(舊殼),' the traditional Chinese characters in the work's title in Korean, literally means 'old shells.' As such, the faces appearing in the painting are implied as masks that have been taken off.

남관(1919~1990)
NAM Kwan

구각(舊殼)된 상(像)
Withered Figures

1988

캔버스에 유채
Oil on canvas

157.6×228cm

국립현대미술관 소장 MMCA Collection

47

황주리(1957~)
HWANG Julie

가면무도회
Masquerade

1988

캔버스, 한지에 아크릴릭
Acrylic on paper on canvas

89.2×135cm (6)

국립현대미술관 소장 MMCA Collection

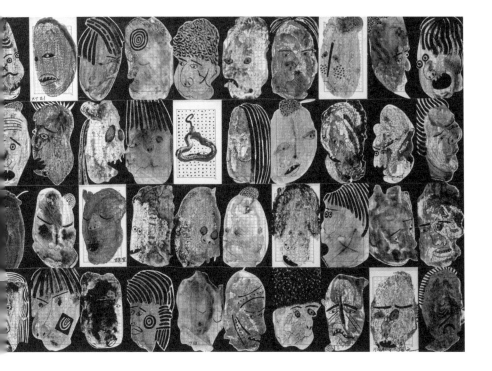

황주리의 ‹가면무도회›는 캔버스에 한지를 붙인 후 그 각각의 한지 위에 아크릴 물감을 사용하여 단숨에 그려낸 여러 가면의 모습을 나열하고 있다. 훗날 흑·회색으로 이루어지는 연작의 출발점이 되는 작품이다. 단숨에 그려낸 여러 익살스런 가면의 모습에서 이후 황주리의 작품을 관통하는 해학과 애수를 함께 느끼게 한다. 작가에게 가면은 단지 거짓이라기보다는 오히려 다양하게 서로 어우러지게 하는 축제의 도구처럼 보인 것은 아닐까?

In *Masquerade*, HWANG Julie presents an array of masks in different shapes. Each of the masks is drawn at once by attaching *hanji* paper to the canvas and drawing with acrylic paint. The work serves as a starting point of the series of works in black and gray depicting various human figures. The humorous masks in the work radiate the senses of humor and sorrow, which are present throughout the artist's later works: could it be also possible to think that the artist considers the masks not as something to conceal the truth but as a festive device to bring people together?

〈붓다, 예수 서울에 입성하시다〉는 1980년대 이후 사회 풍자적 형상 회화를 지속해온 이흥덕의 대표작이다. 인간과 사회의 부조리한 측면들을 비판과 애정 어린 시각으로 투영해온 작가는 급격히 변화하는 시대의 군상들을 거대한 화면 속에 표현한다. 각종 짐승의 탈을 쓴 인간들의 모습과 다양한 인간 군상들은 화면 뒤쪽, 서울로 입성하는 예수와 부처의 환영인파에 떠밀려 나오는 듯 표현되어있다. 화면 우측 누드의 여인은 성경 속 창녀의 모습으로, 성경과는 달리 '자신들은 죄가 없다고 믿는 군중'이 던진 돌에 의해 상처입고 있다. 이는 현대인의 모순된 치부 감추기를 은유하는 것으로 읽힌다.

Budda and Jesus Enter the City is a representative work of LEE Heungduk, an artist who has been creating socially satirical figurative paintings since the 1980s. The artist observes the absurd aspects of humans and society with both criticism and affection, expressing a range of characters on a huge canvas. There are groups of people wearing masks of various animals as well as other groups in LEE's painting, all of whom seem to have been pushed from the back by the crowds welcoming Jesus and Buddha entering Seoul. The woman in the nude on the right represents a prostitute in the story of the Bible. Unlike the Biblical story, however, she is being hurt by stones thrown by 'the mob who believe they are innocent.' This implies a metaphor for the concealing of disgraceful truth by the contemporaries.

이흥덕(1953~)
LEE Heungduk

붓다, 예수 서울에 입성하시다
Budda and Jesus Enter the City

1998

캔버스에 유채
Oil on canvas

218.2×291cm

국립현대미술관 소장 MMCA Collection

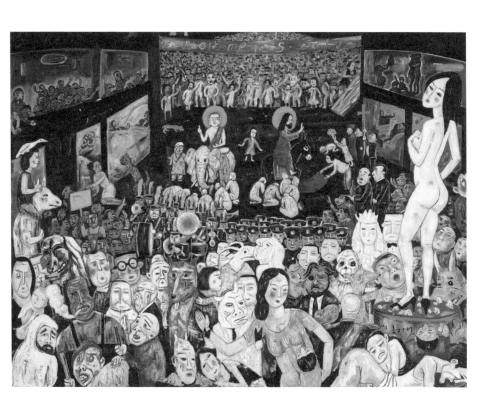

이종교배

Crossbreeding

작가 김기라는 중국과 인도처럼 역사가 긴 나라에서는 가면을 쓴
사람이 제사의식을 통해 신과 인간을 연결하지만, 미국처럼 역사가 짧은
나라에서는 신과 인간 사이에 영웅 캐릭터를 따로 상정한다고 말한다.
다시 말해 동양에서는 인간이 곧 영웅이 될 수 있지만, 미국에서는
슈퍼맨, 원더우먼, 배트맨 등과 같이 초능력을 지닌 캐릭터가 그 역할을
대신한다. 작가는 더욱더 강력한 슈퍼 히어로를 만들기 위해 배트맨의 머리,
원더우먼의 황금 머리띠 등을 하나로 합쳤다. 그러나 그렇게 탄생한 초강력
슈퍼 히어로는 아이러니하게 괴물처럼 보인다.

KIM Kira explains that in countries with a long history, such as
China and India, people wearing masks connect gods and humans by
performing rituals. However, in countries with a short history, such
as the United States, heroic characters are created in the gap between
gods and humans. In other words, while humans can become heroes
in the East, fictional characters with superpowers take on the role of
heroes in the United States. Superman, Wonder Woman, and Batman
are such heroes. In order to create more powerful superheroes, KIM
combined different elements of superheroes, such as Batman's head
and Wonder Woman's golden tiara. However, the resulting super
superheroes ironically resemble monsters.

김기라(1974~)
KIM Kira

슈퍼 히어로즈_몬스터 마스크
Super Heroes_Monster Mask

2009

목조각, 채색, 장식장
Coloring on wooden sculpture, glass cabinet

177×192×93cm

국립현대미술관 소장 MMCA Collection

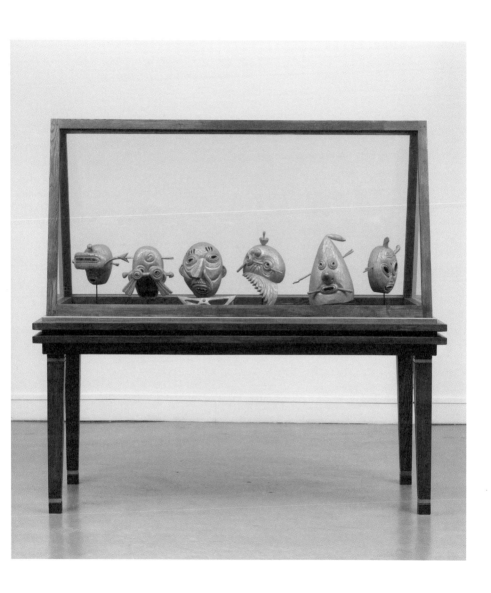

이동기는 일본의 애니메이션 '아톰'과 디즈니 '미키마우스'의 머리를 결합하여 '아토마우스'를 만들었다. 마치 이종교배 실험을 하듯 동양과 서양, 상업예술과 고급예술을 결합시켜 작가만의 고유한 캐릭터를 창조한 것이다. 결과적으로 '아토마우스'는 우리에게 익숙한 듯 낯선 이미지로 남게 되었다. 이후 작가는 이 캐릭터를 자신의 아바타로 삼아 다양한 세계를 활보하게 된다.

LEE Dongi created Atomaus by combining the head of the Japanese animation character Atom and the face of a Disney character Mickey Mouse. The creation of an authentic character—through the combination of the East and the West as well as commercial art and high art—led it to remain as a familiar yet strange image. LEE gradually started using Atomaus to represent himself, expanding into broader artistic realms.

이동기(1967~)
LEE Dongi

아토마우스
Atomaus

1993

캔버스에 아크릴릭
Acrylic on canvas

100×100cm

국립현대미술관 소장 MMCA Collection

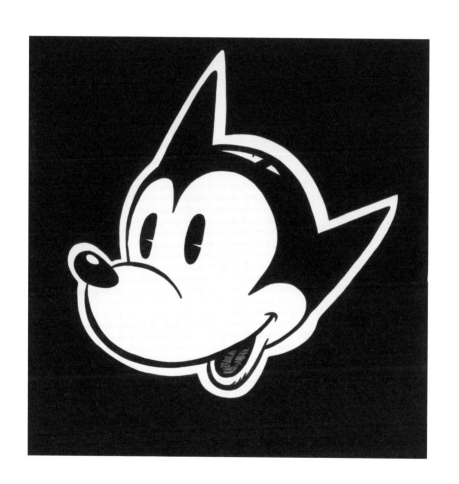

〈신경쇠약 미키 마우스〉는 월트 디즈니 컴퍼니의 1933년작 흑백 애니메이션 「더 매드 닥터」(The Mad Doctor)에서 영감을 받았다. 어느 폭풍우 치는 날, 미친 과학자가 미키 마우스의 애완견 프루토를 납치해서 닭과 융합하려는 실험을 하고 프루토를 구하려는 미키 마우스와 벌이는 소동을 그린 7분 남짓한 단편이다. 작가는 이 줄거리를 뒤집어 오히려 미키 마우스가 미쳐서 폭주하는 상황을 설정했다. 마치 만화의 한 장면처럼 미키 마우스의 신체는 더 이상 알아보기 힘들 정도로 사방으로 흩어지고 검은 칠판용 페인트를 칠한 구조물들이 마치 용암이 솟구치듯 그 위를 휘감고 있다. 그 에너지를 상징하듯 발치에는 모형 장작난로가 활활 타 오르고 있다. 제목을 참고하지 않았다면 멋진 추상조각 정도로 오해했을 작품이다. 평생을 어린아이들의 친구로 살아온 미키 마우스가 결국은 신경쇠약에 걸려 동심의 가면을 벗어던지고 터져버린다는 설정이 보는 이의 상상력을 자극한다. 실제로 아동물로서는 드물게 호러 장르를 선택한 이 영화는 동심을 해친다는 이유로 영국, 독일 등 여러 나라에서 상영금지 처분을 받았다고 한다.

Psychotic Mickey Mouse was inspired by a black and white Disney animation from 1933, titled *The Mad Doctor*. The animation tells a story of a mad scientist who kidnaps Mickey Mouse's pet dog Pluto on one stormy day. The scientist conducts an experiment to merge the dog with a chicken. Mickey Mouse struggles to save the dog. The artists flip the plot of the story and imagines a situation where Mickey Mouse runs wild in madness. In this work, Mickey Mouse's body is scattered all over the place as if it was in a scene from a cartoon. Structures in thick black chalkboard paint are coiling on top of the fragments. At the foot of the figure, fake fireplaces are fiercely burning as if to symbolize the energy of the scene. If it were not for the title, the work could easily be mistaken for a beautiful abstract sculpture. It is intriguing to see the story of Mickey Mouse, a figure whose entire life has been being a friend to children, running into madness because of a nervous breakdown. In fact, as a rare children's horror animation, *The Mad Doctor* was banned in several countries such as UK and Germany for potentially harming children.

김나영, 그레고리 마스
Nayoungim & Gregory. Maass

신경쇠약 미키 마우스
Psychotic Mickey Mouse

2007

목재, 모형 벽난로, 플라스틱, 금속
Wood, faux fireplaces, plastic, metal

215×210×210cm

국립현대미술관 미술은행 소장 MMCA Art Bank Collection

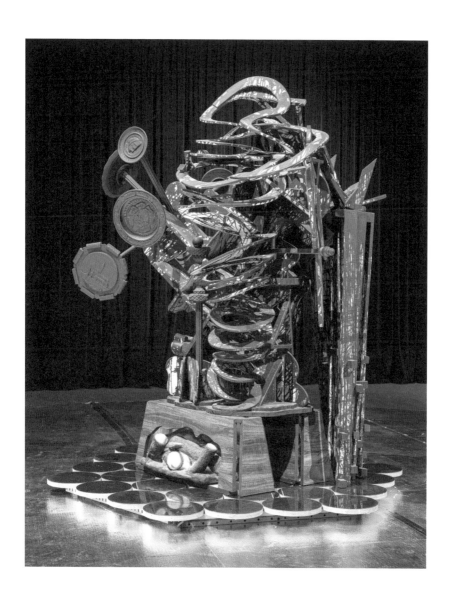

프랑스 출신 작가 오를랑은 성형수술 퍼포먼스로 잘 알려져 있는 신체 미술 작가이다. 한편, 1998년부터 오를랑은 여러 시대와 문명에서 나타나는 다양한 미의 전범들에 관심을 가지면서 피에르 조비에(Pierre Zovile)와 함께 <자기교배> 연작을 제작하였다. 두 작가는 '미의 기준'을 제시하는 특정 지역 및 시대의 인물들과 오를랑의 얼굴을 혼합하는 디지털 이미지들을 제작하였다. "나의 작품은 오늘날의 미의 기준을 대변한다. 하지만 그것은 동시에 미의 반대 기준을 대변하기도 한다."라고 말하는 오를랑은 <자기교배>를 통해 다시 한번 새로운 미의 기준을 제공하고 있다.

French artist ORLAN is a body artist known for her series of plastic surgery operations presented as performances. Since 1998, the artist developed an interest in various archetypes of beauty in different eras and civilizations, which led to a new project with Pierre Zovile. *Self-Hybridization* series is a result of that collaboration. The two artists created digital images that blend ORLAN's face with figures that presented 'standards of beauty' from certain regions and eras. ORLAN explains, "My work represents today's standards of beauty. But it also represents the opposite standard of beauty." In the end, *Self-Hybridization* aims to provide a new standard of beauty beyond the norms of contemporary society.

오를랑(1947~)
ORLAN

자기교배	자기교배
Self-Hybridization	*Self-Hybridization*
1999	1999
컴퓨터 프린터	컴퓨터 프린터
Computer printer	Computer printer
90×60cm	90×60cm
국립현대미술관 소장 MMCA Collection	국립현대미술관 소장 MMCA Collection
© ORLAN / ADAGP, Paris – SACK, Seoul, 2022	© ORLAN / ADAGP, Paris – SACK, Seoul, 2022

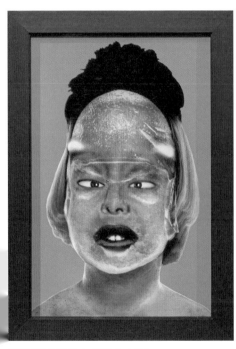 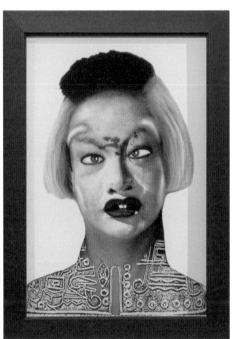

한효석은 역사적으로 전개된 미(美)와 추(醜)의 역학관계에 질문을 던진다. 이는 예술적, 미학적 범주를 넘어 견고하게 굳어진 여러 사회적 규범에 대한 비판적인 질문으로 이어진다. 개인의 정체성처럼 해석되는 얼굴의 표피 한 꺼풀을 벗겨내면 사회 구석구석에 만연하는 편견과 배제는 무의미해진다. "고깃덩어리 얼굴을 그린 회화 작품을 통해 동물로서의 본질을 망각한 채 온갖 욕망에 사로잡혀 사는 우리의 참모습을 보여 주고자 했다. 정면을 응시하고 있는 모델의 얼굴을 조우하는 우리는 한순간 빛이 번쩍이며 지금까지 망각에 젖어 살아 온 자신들의 오만함과 마주하게 될 것이다."

HAN Hyoseok questions the historically developed dynamics of beauty and ugliness, which leads to critical questions about various social norms that have been firmly established beyond artistic and aesthetic categories. While the face of an individual is interpreted as representing one's identity, it is true that the prejudice and exclusion rampant throughout society become meaningless when just one layer of skin is removed from it. "By presenting a painting of face as a lump of flesh, I wanted to show the truthful look of us who live in the grip of all kinds of desires, oblivious of our nature as animals. When we encounter the face of the model staring straight into us, there will be a flash of light, and we will confront our own arrogance of living in oblivion until that point."

한효석(1972~)
HAN Hyoseok

감추어져 있어야만 했는데 드러나고 만
어떤 것들에 대하여 10
*Unmasked Exposing What Lies
Beneath 10*

2008–2009

캔버스에 유채
Oil on canvas

250×178cm

국립현대미술관 소장 *MMCA Collection*

감추어져 있어야만 했는데 드러나고 만
어떤 것들에 대하여 11
*Unmasked Exposing What Lies
Beneath 11*

2008–2009

캔버스에 유채
Oil on canvas

250×178cm

국립현대미술관 소장 *MMCA Collection*

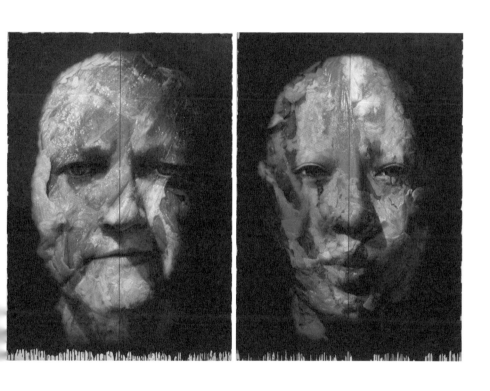

신학철은 1980년대 한국 민중 미술의 대표작가들 중 1970년대 한국아방가르드협회(AG)에서 활동하는 등 다양한 실험 미술을 시도해 온 드문 경력의 소유자다. <변신3>은 그 실험의 경험이 이후 신학철의 대표 이미지가 된 회화적 몽타주 작업으로 막 전환되려는 시점인 1980년에 제작됐다. 작가는 캔버스 위에 잡지 등의 인쇄물에서 오려낸 이미지들을 조합하여 마치 가면과 같은 우스꽝스러운 이미지를 만들어 냈다. 이를 통해 신학철은 현대 물질문명에 휘둘리며 비명을 지르고 있는 현대인들의 광대 같은 모습을 강조하고 있다.

SHIN Hakchul represents a generation of Minjung artists that were active in the 1980s. He is also known for his involvement in the AG (Korean Avant Garde Association) in the 1970s with a range of experimental artistic practices. *Transformation 3* was produced in 1980, the year of his artistic transition when his experiences of experiments were about to turn into his unique painterly montage works that later came to represent his practice. On the canvas, the artist creates a comical image resembling a mask, combining cutout images from printed matters. In this work, the artist emphasizes the clownish look of the contemporaries that are screaming in their minds as they are engulfed by the modern materialist civilization.

신학철(1943~)
SHIN Hakchul

변신 3
Transformation 3

1980

캔버스에 콜라주
Collage on canvas

43×39cm

국립현대미술관 소장 MMCA Collection

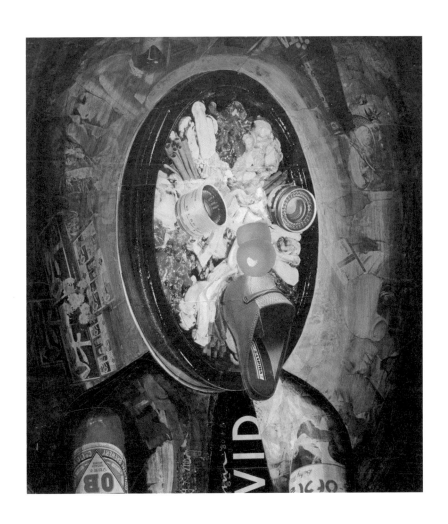

윌리엄 켄트리지(William Kentridge)의 <코1(가위)>는 니콜라이 고골 (Nikolai Gogol)이 쓴 소설 「코」(1836)에서 출발한다. 어느 날 한 남자가 자신의 코가 없어진 것을 알고 코를 찾아 도시 이곳저곳을 헤맨다. 마침내 자신의 코를 만났지만 남자보다 높은 지위에 올라간 코는 그를 무시하고, 코를 되찾기 위한 남자의 노력은 그의 낮은 지위로 인해 번번이 실패한다는 내용이다.

　　　이 조각에서 코는 마치 사람처럼 가위를 다리 삼아 우뚝 서 있다. 소설 속 지위가 높아진 코처럼 어딘가 거만함이 느껴지기도 하지만, 결국 코털을 깎는 가위에 불과하다는 점에서 실소를 자아내기도 한다. 이미지가 실체보다 더 지위가 높아지면 어떤 일이 벌어질지에 대한 상상이 흥미롭다.

William KENTRIDGE's *Nose1 (Scissors)* is based on Nikolai Gogol's novel William KENTRIDGE's *Nose* (1836). One day, a man discovers that his nose goes missing and wanders around the city looking for his nose. Finally, he encounters it, however, the nose is now in a higher position than the man and refuses to talk to him. It then gets arrested while trying to sneak out of the city.

　　　In KENTRIDGE's sculpture, the nose stands tall like a human, using open scissors as its legs. There is a sense of arrogance in the standing posture, but it can also invite absurd laughter when one thinks that the scissors might groom someone's nose hair. The imagination gets more curious as it poses a situation where an image acquires a higher status than reality.

윌리엄 켄트리지(1955~)　　　코1(가위)
William KENTRIDGE　　　*Nose1 (Scissors)*

2007

청동
Bronze

30×16×14cm

국립현대미술관 소장 MMCA Collection

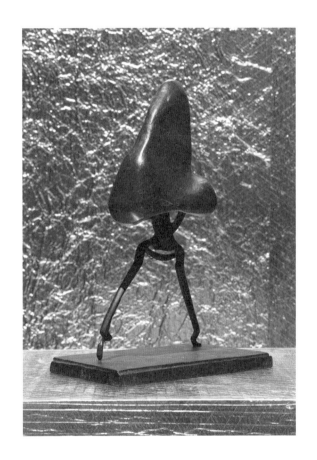

그림자

Shadows

곽남신
김기찬
김영균
김희원
난다
크리스티안 볼탕스키
니키 드 생팔
양정욱
우주+림희영
조덕현
천경우

KWAK Namsin
KIM Kichan
KIM Young Kyun
KIM Heewon
Nanda
Christian BOLTANSKI
Niki de SAINT PHALLE
YANG Jung Uk
Ujoo+LimHeeYoung
CHO Duckhyun
CHUN Kyungwoo

김희원은 현실과 이미지, 그 사이의 애매한 지점을 탐구한다. ‹누군가의 샹들리에 04›는 아마도 '누군가의' 공간에 걸려서 익숙한 풍경이었을 이 고풍스러운 유럽식 샹들리에를 초고화질 동영상으로 꼼꼼하게 기록한 내용이다. 촛불이 다 타서 저절로 꺼지는 약 4시간 30분 동안 동영상은 이어진다. 실제 샹들리에처럼 김희원의 동영상이 재생되는 TV 화면도 나름대로 밝게 빛나며 조명의 역할까지 해낸다. 그렇다면 어떤 의미에서 이 둘은 동일한 기능을 한다고도 할 수 있다. 이런데도 영상으로 재현된 샹들리에는 그저 현실의 샹들리에를 흉내 낸 '가면'에 불과하다고 쉽게 말해 버릴 수 있을까?

KIM Heewon is an artist whose work explores the ambiguous area between reality and image. *Someone's Chandelier* is an ultra-high-definition video of an antique European-style chandelier, which might have been part of a familiar everyday scenery of 'someone.' The video plays for about four hours and thirty minutes as the candles on the chandelier burn out by themselves. The television screen on which the artist's video is played also works as a kind of lighting with its illumination. It would then be possible to say that the two objects perform the same. If this is the case, can anyone easily say that the video representation of the chandelier is merely an imitating 'mask' of the real chandelier?

김희원(1982~)
KIM Heewon

누군가의 샹들리에 04
Someone's Chandelier 04

2021

4K 비디오, 4시간 35분 35초, 65인치 LED 디스플레이, 목재 액자
4K video, 4hr. 35min. 2sec., 65 inch LED display, black wood frame

149.5×87cm

작가 소장 Courtesy of the artist

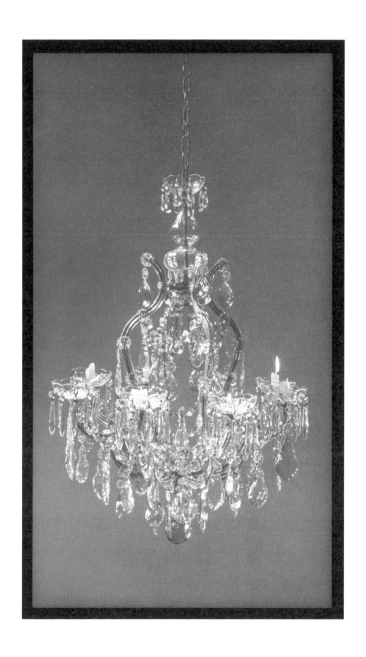

신나게 오줌을 쏘아 올리는 남성의 그림자는 외관상 '멀리 누기'라는
사내아이들 특유의 놀이를 연상시키는 동시에 남성 중심적인 세계관을
생각하게 한다. 화면에 드리운 그림자는 캔버스 밖에 누군가, 즉 이 그림자의
진짜 주인이 있음을 암시하는 동시에 실은 그저 스프레이 얼룩에 불과한
추상 회화라는 전혀 다른 해석을 가능하게 한다. 대체 이 그림자의 실제
주인은 누구일까? 이렇게 여러 모순적인 요소가 복잡하게 얽혀있는 와중에,
오줌 줄기는 다시 캔버스로부터 현실 공간으로 뻗어나가 확장되고 있다.
확장이라고는 했지만 동시에 회화의 상상적 공간을 현실로 제한하는 역할도
수행하고 있으며, 이 오줌 줄기는 환영인 동시에 캔버스에 실제로 그림자를
드리우는 물리적 실체라는 이중적 모순을 품고 있다.

The shadow of a man pissing up into the air in KWAK Namsin's
Pissing Farthest reminds us of the pissing contest that adolescent boys
usually play. At the same time, it evokes a male-centered worldview.
The shadow cast on the image suggests that there is someone outside
the canvas who is the real owner of the shadow and it might be just an
abstract painting in the form of a sprayed stain. Then, who on earth
would be the real owner of this shadow? In this work, contradictory
elements are intricately intermixed while the stream of urine expands
from the canvas to the real world, and such an expansion also limits
the imaginary space of the painting to reality. Casting a shadow on the
canvas, the stream of urine is embedded with an ironical ambivalence
of being an illusion and a physical entity at once.

곽남신(1953~)
KWAK Namsin

멀리누기
Pissing Farthest

2002

판넬에 스프레이, 스테인리스
Spray on panel, stainless steel

260×140×5.5cm

국립현대미술관 소장 MMCA Collection

<그림자 연극>은 철판을 잘라 만든 꼭두각시 형상에 빛을 비춰 생기는 그림자로 구성된 작품이다. 그림자의 형태와 움직임을 통해 이야기를 재현하는 방식은 동서양을 막론하고 존재하는 전통이다. 크게 확대되고 반복적으로 비치는 그림자들은 관객에게 괴기스러운 체험을 제공한다. 그러나 작가는 관객들이 특정한 방향의 해석에만 매이지 않기를 바란다. "예를 들어, 이 강한 불빛에서 어떤 이는 경찰의 탐조등을, 어떤 이는 무대의 화려한 조명을 떠올릴 수도 있다. 그림자의 형상을 익살스럽게도 흉악하게도 느낄 수 있다. 이는 각자의 살아온 배경과 경험이 다르기 때문이다. 작품은 결국 관객이 완성하는 것이다."

Theatre of Shadows (Théâtre d'ombres) consists of shadows created by illuminating light on the puppets made of cutout metal plates. Representing stories through the shape and movement of shadows is a common tradition in both the East and the West. The enlarged shadows are repeatedly projected, facilitating the audiences to have grotesque experiences. However, the artist does not want the audiences to be preoccupied with particular interpretations. "For example, seeing this intense light, one might think of a police searchlight and another might think of the splendid lighting of a stage. One can also feel the shape of the shadow as being both humorous and horrible. This is because their backgrounds and experiences are different. The work is ultimately completed by its audiences."

크리스티앙 볼탕스키
(1944~2021)
Christian BOLTANSKI

그림자 연극
Theatre of Shadows (Théâtre d'ombres)

1986

철사, 철판, 램프, 선풍기
Wire, metal, light projectors, fan

70.5×80×41.5cm

국립현대미술관 소장 MMCA Collection

"어둠 먹는 기계는 어둠을 부르는 가면으로 만들어져 있으며 어둠 속에서 수많은 이빨을 움직이며 강한 빛을 터트림으로써 어둠이 가진 에너지를 흡수한다. 어둠 속에 흐르고 있는 어둠에너지는 강한 빛에 의해 흡수되는 데 이 어둠에너지가 더할 수 없을 정도로 축적되면 마치 블랙홀처럼 검은 구멍을 형성한다. 설계자 1과 2는 이것이 다른 세계와 연결된 통로가 될 수 있을 것으로 기대하고 있다."

우주+림희영의 작업은 허황되고 알 수 없는 것들, 그리고 현실에서 보이지 않는 것들에 대한 허구적인 이야기에서 출발한다. 이는 직접적인 기록이나 묘사를 피하면서도 현실의 부조리하고 불편한 모습들에 대한 언급이 가능하게 하는 장치이다. 어쩌면 중심축이 한쪽으로 기울어 버린 듯한 세계에서 허구의 세계가 균형을 맞추는 역할을 할 것으로 기대하기 때문이다.

"The dark eating machine is made of masks that summon darkness, moving its numerous teeth in the darkness and emitting strong light to absorb the energy of darkness. The dark energy that flows in the darkness is absorbed by the strong light. When this dark energy is accumulated to the limit, it forms a hole that is as dark as a black hole. The designers number one and two are expecting it to be a gateway to another world."

Ujoo+LimHeeYoung's work begins with a fictional story about vague and unknown things and things that are invisible in reality. Their work is a device that enables us to avoid direct documentation or depiction while mentioning the absurd and uncomfortable aspects of reality. It might be because they expect the fictional world to play a role in balancing the world whose central axis is tilted to one side.

우주+림희영
Ujoo+LimHeeYoung

춤추는 가면, 어둠 먹는 기계
Temptation of the Dancing Mask_Dark Eating Machine

2011

철, 전자장치, DC모터, LED, 불에 태운 나무
Steel, microprocessor, DC motor, LED, burnt plywood

55×44×46cm

국립현대미술관 미술은행 소장 MMCA Art Bank Collection

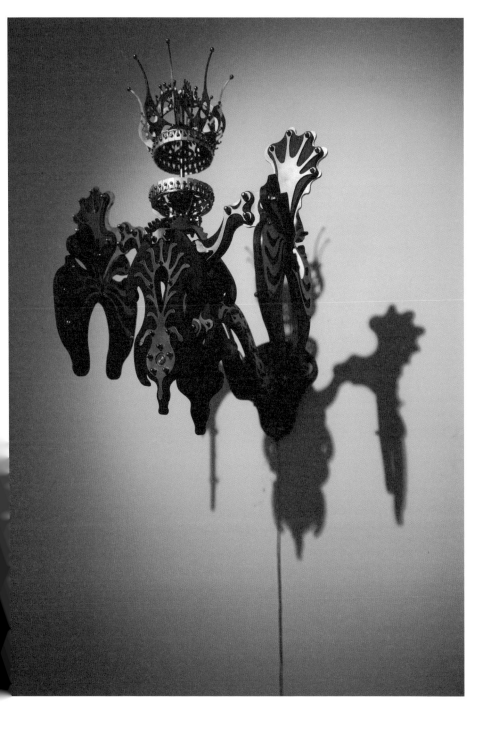

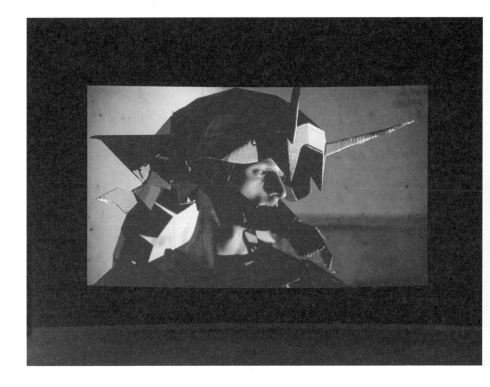

김영균(1977~)
KIM Young Kyun

브레스 #2
Breath #2

2018

단채널 비디오, 3분 30초
Single-channel video, 3 min. 30 sec.

작가 소장 Courtesy of the artist

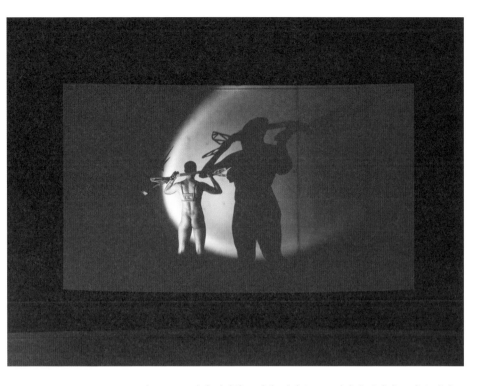

<브레스 #2>는 어떤 내밀한 공간을 배경으로 공연자가 골판지로 만든 여러 가면과 의상을 입어본다는 단순한 줄거리의 영상 작업이다. '숨'이라는 제목이 의미하듯이 가면을 바꿔 쓰면서 존재를 변화시키는 것은 결국 사회에 적응하려는, 그래서 살아있고자 하는 절실한 몸부림이다. 그래서 한 의상에 달린 플라스틱 호스를 부는 날카로운 소리가 곧 살아있다는 신호처럼 느껴진다. 이것은 독일 유학 중 이방인으로서 느끼는 작가의 개인적인 고백인 동시에 세상에 내던져진 우리 모두의 절박함이기도 하다. (성소수자였던 이 공연자도 독일에서 성장하며 겪었던 다양한 상처들을 떠올렸다고 한다.)

Breath #2 is a video with a simple plot where a performer tries different masks and costumes made of cardboard in an intimate space. As the title suggests, changing one's existence by changing masks is ultimately a desperate struggle to stay alive and adapt to society. The piercing sound of blowing a plastic hose on the performer's costume feels like a sign of staying alive. The work as a whole is the artist's confession of his feelings as an outsider in Germany. At the same time, it expresses the desperation shared by all of us as beings that are inadvertently thrown into this world. (The performer in the video also confessed that he recalled his traumas as a sexual minority growing up in Germany during his performance.)

〈믿는 것이 보는 것이다〉는 보는 것이 믿는 것이라는 서양식 속담을 뒤집어 놓는다. 시각적으로 가장 객관적인 매체라고 흔히들 인식하는 사진을 통해 '보는 것' 또는 '본다고 믿는 것'에 대한 근본적인 의문을 제시한다. 이를 위해 작가는 시각 장애가 있는 어린이와 청소년이 참여한 일종의 사진적 퍼포먼스를 기획했다. 참여자들에게 다른 이들에게 자신이 어떻게 보여진다고 믿는지를 묻고 대화하는 시간을 장노출로 기록했다. 결과적으로 30~40분의 시간이 응축된 이미지가 남게 되었다. 과연 이 이미지는 가면일까, 아니면 본의 아니게 가면을 살짝 벗은 순간의 모습일까?

Believing Is Seeing is a paradoxical twist of a Western proverb, "Seeing is believing." Through the medium of photography, which is usually thought of as the most visually objective medium, the work poses a fundamental question on 'seeing' or 'believing to see.' To realize this idea, the artist organized a photographic performance with visually impaired children and teens. He asked the participants how they believed they were seen by others. While the conversations took place, he composed a long exposure shot. What was created was an image embedded with more than thirty minutes of time. Then, can we think of this image as capturing a mask? Or is it showing a brief moment of unintentionally taking off a mask?

천경우(1969~)
CHUN Kyungwoo

믿는 것이 보는 것이다 #7-1, #7-2, #7-3
Believing Is Seeing #7-1, #7-2, #7-3

2006-2007(2012년 인화)

C-프린트
C-print

136×103cm (3)

국립현대미술관 소장 MMCA Collection

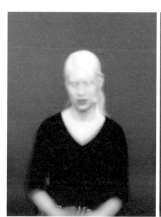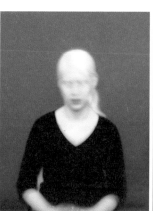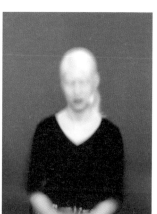

니키 드 생팔(Niki de Saint Phalle)은 1965년에 친구인 클라리스 리버스(Clarice Rivers)의 임신한 몸에 영감을 받아 풍만한 몸매를 가진 '나나'를 처음 제작하였다. 이후 부푼 가슴과 배, 원색의 밝고 강렬한 색채의 전형적인 ‹나나› 연작을 지속적으로 제작한다. '나나'는 여성에게 아름다움의 기준을 요구하는 세상의 시선에 대항하는 존재이자 작가 자신의 또 다른 자아이기도 했다. 어색하고 불균형한 자세, 날씬한 금발 미인이 아닌 뚱뚱한 흑인의 몸매, 고상한 물감이 아닌 싸구려 페인트로 칠해진 이 조각이 만약 나름대로 아름답다고 느껴진다면 우리도 어느새 한 겹의 가면을 벗은 것일지도 모른다.

In 1965, Niki de SAINT PHALLE created Nana, a female figure with a voluptuous body, inspired by the pregnancy of her friend Clarice Rivers. Since then, the artist has been creating a series where Nana showed its bulging breasts and belly as well as bright and intense primary colors. For her, Nana is a resistant against the conventional view of women to follow the standardized beauty and also a representation of her alter ego. If one feels beauty in Nana's awkward and unbalanced posture, its fat black body in cheap paint that is not slender with blonde hair, it might mean that he or she has taken off the mask without even realizing it.

니키 드 생팔(1930~2002)
Niki de SAINT
PHALLE

검은 나나(라라)
Black Nana (Lara)

1967

폴리에스테르에 채색
Color on polyester

291×172×100cm

국립현대미술관 소장 MMCA Collection

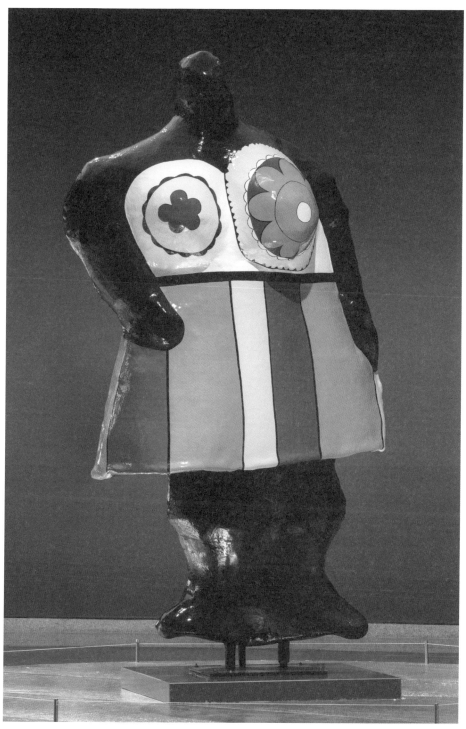

김기찬은 급격한 산업화와 도시화로 지방 인구가 서울로 대거 유입되던 1970–1980년대에 서울 일대의 골목을 기록한 사진작가다. 작가는 화려한 도시 뒤에 숨은 뒷골목을 촬영하면서 그 주거 환경의 삭막함과 각박함, 그리고 이와는 대조적으로 정감 있고 소박한 사람들을 담아내었다. 그의 작품 속 골목은 단지 비좁고 낙후된 길이 아니라 주민들의 통로이자 휴식처이고, 아이들에겐 더할 나위 없는 놀이터였다. 작품 속 아이들은 당시 유명했던 코미디 프로그램에 등장했던 캐릭터를 흉내 내면서 깔깔대고 있다. 흉내라는 가면을 씀으로써 이 아이들은 가난한 현실의 제약을 넘어 무엇이든 될 수 있는 상상의 세계를 경험할 수 있었을 것이다.

KIM Kichan is a photographer who documented alleyways in Seoul in the 1970s and 1980s when there was a massive influx of populations from outside the city. While capturing the desolate and barrenness of the city, he documented the amiable and modest atmosphere of alleyways and their residents. The alleyway we see in *Jungrimdong, Seoul, November. 1988* is not just a narrow and underdeveloped path. It appears as a passage and resting place for residents, which also works as a place of livelihood for ordinary people. It must also have been a perfect playground for children: The children in the photo are imitating a character from a famous comedy show at that time. By wearing the mask of mimicking, the children must have experienced an imaginary world beyond their limitations.

김기찬(1938~2005)
KIM Kichan

서울 중림동 1988. 11
Jungrimdong, Seoul, November. 1988

1988

젤라틴 실버 프린트
Gelatin silver print

27.9×35.6cm

국립현대미술관 소장 MMCA Collection

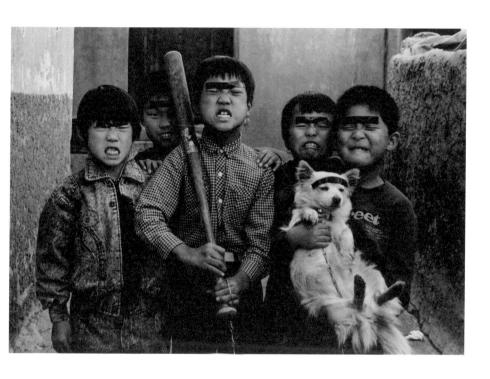

조덕현은 자신과 아버지, 아들, 그리고 어머니, 아내, 딸의 삼 대에 걸친 인물상을 당시로서는 희귀했던 모핑 기법을 이용하여 합성한 후 여러 겹의 비단에 인쇄하여 겹쳐 놓았다. 인물들은 각 세대의 서로 다른 시간과 기억을 품고 있으면서도 혈연이라는 유전자 고리로 이어져 있다. 서로 겹쳐지면서 만들어낸 최종적인 얼굴은 각각 부계와 모계의 표준적인 모습일 수도 있지만 다른 의미에서는 고유의 개성이 사라지고 가족이라는 집단을 대표하는 얼굴 같기도 하다. 이런 의미에서 결국 우리 모두의 얼굴은 그 자체로 각각의 역사가 현재에 누적되어 있는 하나의 가면일 수도 있겠다.

In *Paternal Maternal*, CHO Duckhyun overlaps the images of himself, his father, his son, his mother, his wife, and his daughter. They span three generations from different periods and with diverse memories. Yet, they are connected by a genetic relationship of blood ties. The resulting image of faces made of overlapped images can be thought of as common appearances of the paternal and maternal lines. However, it is also possible to consider them as the most depersonalized and collective images representing a family. In this sense, we can also consider our faces as masks in which our own histories are accumulated.

조덕현(1957~)
CHO Duckhyun

부계 모계
Paternal Maternal

2000

비단, 컴퓨터 전사
Silk, computer print

70×70×93cm (2)

국립현대미술관 소장 MMCA Collection

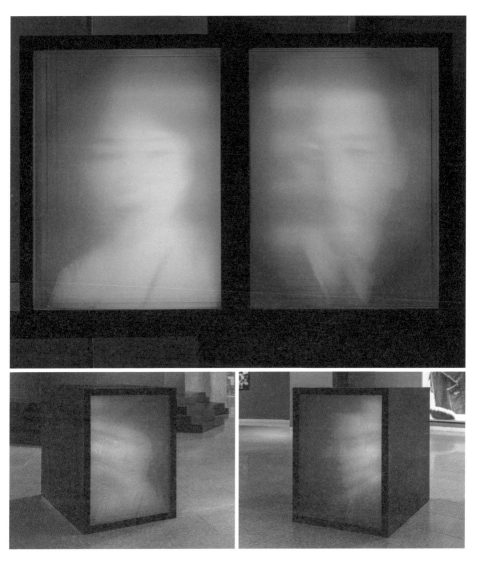

양정욱의 <서서 일하는 사람들 #11>은 동시대를 살아가는 인간 동료들에 대한 작가의 관찰을 바탕으로 이어지는 같은 제목의 연작 중 하나다. '서서 일한다' 는 것은 단순히 물리적인 현상만을 의미하는 것이 아니라 고용이 불안정한 임시직 노동자들의 주된 근무형태가 서서 움직이는 것이라는 작가의 관찰에 기반하고 있다. 이들의 불안정한 현재 너머에는 과거의 직업과 습관이 있을 것이고, 서서 일하며 하루를 보내는 이들은 "과연 무엇으로 하루를 보낼지" 궁금했다고 작가는 말한다. <서서 일하는 사람들 #11>에 등장하는 #11은 과거에 라디오 공장에서 불량품을 골라내는 전문기술자였으나 라디오가 역사의 뒤안길로 사라진 지금은 회사의 경비직으로 일하고 있다. 그에게 여전히 남은 습관이 있다면, 주파수의 미세한 이상을 잡아내던 그 예민한 감각이 보내는 하루는 어떨까 하는 연민과 공감이 뒤섞인 감정이 이 독특한 형태의 구조물에 스며있다. 화물용 엘리베이터에 설치된 이번 버전은 그 불안정함을 증폭시키며 일상에서 수없이 만나는 타인들의 가면 너머 또 다른 모습에 대한 우리의 관심을 유도한다.

YANG Jung Uk's *Standing workers No.11* belongs to a series with the same title, which is based on the artist's observations on other human beings as colleagues living in the same era. 'Standing while working' does not just indicate a physical state. The artist observes that it is the precarious temporary workers that are standing while working. However, beyond their precarious present, there shall be jobs and habits that they once had. The artist says he thought about those who were standing while working. "What are they spending time with?" The protagonist of *Standing workers No.11* is a guard at a factory. In the past, he was an expert technician picking up defective products in a radio factory. However, radio has now become a thing of a past. One habit that he still maintains is his sensitive perception that he used to practice when detecting anomalies in frequencies. With such a sensibility, he feels compassion and empathy at the same time. The unique structure is embedded with such a feeling. In the current exhibition, the work is installed in a freight elevator. It amplifies the sense of instability, inviting us to be more curious about what lies behind the masks worn by countless others we encounter in our daily life.

양정욱(1982~)
YANG Jung Uk

서서 일하는 사람들 #11
Standing Workers No.11

2015

목재, 모터, 복합재료
Wood, motors, mixed media

190×120×70cm

백아트 소장 Collection of Baik Art

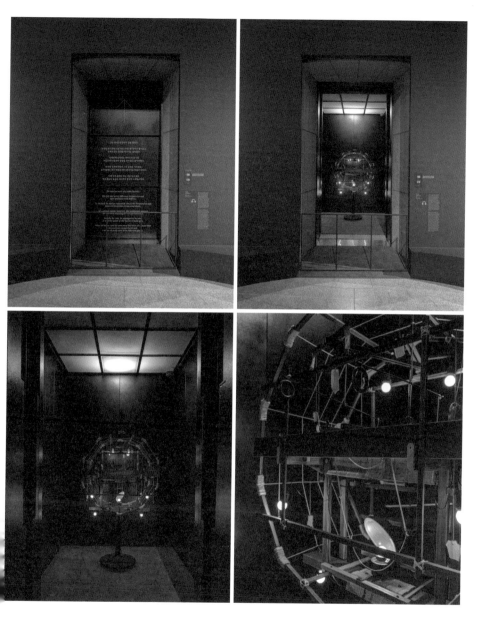

난다(1969~)
Nanda

여우털 군단
Crazy Fox Corps

2008

잉크젯 프린트
Inkjet print

107×241cm

국립현대미술관 소장 MMCA Collection

난다는 근대기의 거리를 재현한 영화 촬영소에서 서구 문물을 일찍 받아들인 신여성 〈모던 걸〉 연작(2006-2009)을 연출했다. 〈여우털 군단〉은 작가 자신이 여우털을 목에 두른 모던 걸로 분하여 경성 시가에서 '발리우드식' 군무를 추는 작품이다. 디지털 사진의 특성으로 무한대로 증식할 수 있는 작가의 아바타는 동시에 여러 장소에 존재할 수 있는 메타버스 식 자아이기도 하다. 여성의 숫자가 늘어갈수록 그들이 품은 욕망과 쾌락 역시 커지는 듯하다.

Crazy Fox Corps is a work from the series *Modern Girl* (2006–2009), a series that takes a movie set of a recreated street from the modernization period as its background. In the work, the artist turns herself into a 'modern girl' with fox fur around her neck and dances in a group on the streets of Gyeongseong (former name of Seoul) like a Bollywood movie. As she can infinitely multiply herself digitally, the 'modern girl' figure can also be seen as a metaverse version of herself. As the number grows, the desire and pleasure of the 'modern girl' avatars seem to increase, too.

저항의 가면

Masks of Resistance

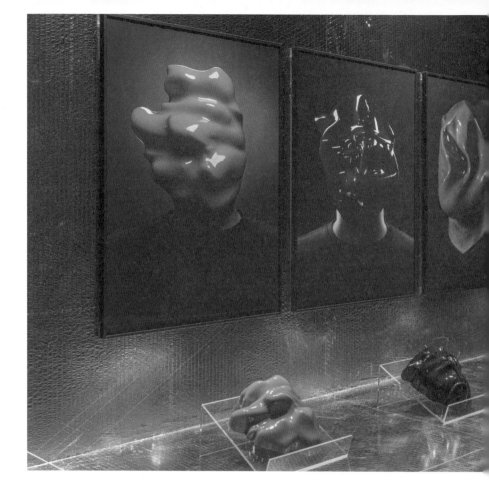

자크 블라스(1981~)
Zach BLAS

얼굴 무기화 세트
Facial Weaponization Suite

2012–2014

비디오 설치; 단채널 비디오, 컬러, 사운드, 8분 10초; 플라스틱 마스크 4개,
디지털 프린트 12점
Video installation; single-channel video, color, sound, 8min. 10sec.:
4 plastic masks, 12 digital prints

마스크 masks 21.6×19×10.5cm (4)
프린트 prints 30.5×45.7cm×(7), 45.7×30.5cm, 50.8×76.2cm (4)

국립현대미술관 소장 MMCA Collection

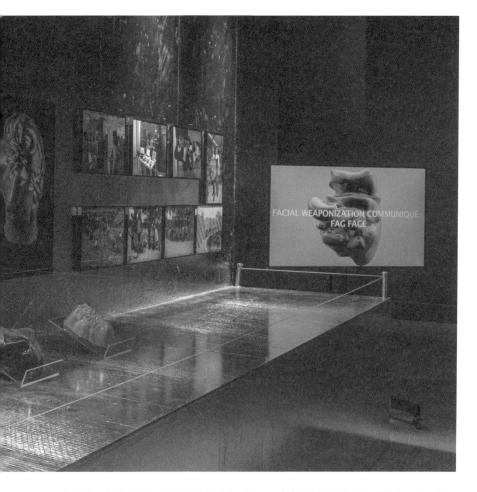

자크 블라스(Zach Blas)의 〈얼굴 무기화 세트〉는 지역사회를 기반으로 진행한 워크숍을 통해 안면인식 기술로 탐지할 수 없는 네 개의 무정형 형태의 가면을 만들었다. 가면들은 각각 성소수자, 유색인종, 이슬람 여성, 불법이민자 등 사회적 약자를 대변한다. 작가는 가면이 정치권력에 대항하는 집단적 운동에서 개인을 지키기 위한 용도로 사용되었듯이 안면인식 기술로 식별 불가능한 형태의 가면으로 얼굴을 "무기화"하여 소수자에게 가해지는 사회적 차별에 대응하고자 했다.

Zach BLAS's *Facial Weaponization Suite* presents a collective of different masks. These masks are created by synthesizing facial data from community-based workshop. The amorphous masks can stay undetected by facial recognition. Each mask represents social minorities that are discriminated for being minorities in terms of their gender, race, religion, and immigration status. Just as masks have been used to protect individuals in collective movements against political authorities, the artist employs amorphous masks undetected by facial recognition to "weaponize" faces in response to social discrimination inflicted on minorities.

박영숙의 <미친년 프로젝트>(1999–2005)는 가부장적 사회 속 지난한 삶을 살아온 여성들의 모습을 담고 있다. '미친년'이라는 비난은 단지 특정 개인의 문제가 아니라 현실적, 제도적 틀 안에서 스스로 의미를 찾고자 하는 모든 여성들이 숙명처럼 듣게 되는 호칭이라는 자조적인 비판 의식이 담겨있다.

　　<헤이리 여신 우마드–풍요의 여신, 분노의 여신, 사랑의 여신, 죽음의 여신> 역시 같은 맥락에서 박영숙이 선택한 전략적 이미지다. '우마드 (WOMAD)'는 여성(woman)과 유목민(nomad)을 결합한 조어로서 작가는 이 단어를 현대적 여신의 이름으로 받아들인다. 돌풍이 심하게 불던 어느 날 작가는 동서남북 네 방위를 책임지는 네 명의 여신을 만나고 그 경험을 토대로 이들을 사진으로 기록했다. 각각 동쪽은 풍요, 서쪽은 사랑, 남쪽은 분노, 북쪽은 죽음을 담당하는 여신들이다. 그리고 보니 'WOMAD'라는 이름은 또한 '미친년'으로도 읽힌다.

In her *Mad Women Project* (1999–2005), PARK Young-sook captures the lives of women who lived through struggles over time. The work delivers self-deprecating criticism of being 'mad women,' which is not actually about one's mental state but an inescapable attack on all women who try to seek to find meaning on their own within the practical and institutional framework.

　　The images employed in the work are strategically chosen in the same context. The word 'WOMAD' is a word that combines 'woman' and 'nomad.' The artist takes the word as the name for modern goddesses. According to the artist, she encountered four goddesses guarding the four points of the compass on one fine day with a strong gust of wind. She then documented the goddesses in photography. The goddesses of the East, West, South, and North are respectively responsible for fertility, love and passion, indignation, and death.

박영숙(1941~)
PARK Young-sook

헤이리 여신 우마드–풍요의 여신, 분노의 여신, 사랑의 여신, 죽음의 여신
WOMAD–Goddess of Mother Earth and Fertility, Goddess of Indignation, Goddess of Love and Passion, Goddess of Salvation and Death

2004

디지털 C-프린트
Digital C-print

170×120cm (4)

국립현대미술관 미술은행 소장 MMCA Art Bank Collection

이용백(1966~)
LEE Yongbaek

엔젤 솔저
Angel Soldier

2005

HD 비디오, 24분 17초
HD Video, 24 min. 17 sec.

국립현대미술관 소장 MMCA Collection

<엔젤 솔저>는 화려한 인조 꽃이 인쇄된 천을 배경으로 같은 꽃무늬 천으로 위장한
군복을 입은 6명의 군인들이 극도로 천천히 움직이는 영상이다. 군인들이 입은 군복에는
'Windows', 'Quicktime', 'Word', 'Explorer' 등의 IT 대기업들의 로고가, 명찰에는
'보이스', '피카소', '뒤샹', '백남준', '다빈치' 등 미술사의 대가들의 이름이 적혀있다. 예술의
위상 자체가 모호해지고 예술가는 독창적 창조가 아닌 복제물의 차용과 재구성이라는
시뮬레이션 형식을 빌어서만 자신을 표현할 수 있는, 그럼에도 치열하게 무언가와 전투를
벌이는 존재로 나타난다.

Angel Soldier is a video showing six soldiers in military uniforms with floral patterns
slowly moving against a fabric background and a floor printed with colorful artificial
flowers. On the soldiers' uniforms are logos from big IT corporations such as
'Windows,' 'Quicktime,' 'Word,' 'Explorer.' Their name tags are decorated with
the masters of art history, including 'Beuys,' 'Picasso,' 'Duchamp,' 'Nam June Paik,'
and 'DaVinci.' In this work, the artist appears to be subject to a condition where the
status of art itself becomes ambiguous. There, artistic expressions can be done only
in the form of simulation, not through authentic creation but through appropriation
and reconstruction of replicas. Nevertheless, the artist engages in a fierce battle.

조습은 특유의 B급 감성의 연출사진으로 한국 사회의 부조리함을
풍자한다. 그의 <묻지 마> 연작(2005)은 한국 현대사의 주요 장면들의 '흉내
내기'를 통해 그것을 동시대적으로 번안하는 시도다. 이 연작에 포함된
<물고문>과 <임춘애>는 각각 1987년 초 박종철 고문치사 사건과 86 서울
아시안 게임 육상 3관왕에 오르며 깜짝 스타로 등장했던 임춘애 선수에
대한 우리의 기억을 다룬다. 하나는 공권력에 의한 폭력사건, 다른 하나는
대중과 미디어가 만든 우상으로 성격은 서로 다르지만, 공동체의 기억을
통해 이미지로 각인된 일종의 가면이라는 점에서 공통점이 있다. 여기에
물고문 장면 뒤에서 태연히 목욕하는 사람들이나 임춘애로 분장한 작가
자신의 우스꽝스러운 모습을 통해 그 가면조차도 우리 기억이 씌우는 또
다른 가면으로 왜곡되고 있는 것은 아닐지 작가는 우리에게 묻는 듯하다.

With his quirky sensibility of kitsch in staged photography, JO Seub
satirizes the absurdity of Korean society. In the *Do Not Question*
series (2005), the artist selects key scenes from Korea's modern history
and adapts them in a contemporary manner. Included in the series,
Water Torture and *Lim Chun-ae* respectively deal with the memories
of the torture and death of Park Jong-cheol in early 1987 and Lim
Chun-ae, a track and field athlete who came to the spotlight during
the 1986 Asian Games in Seoul for winning three gold medals. While
the former is an incident of state violence and the latter is a case of
an idol created by the public and mass media, they are similar in the
sense that both of them exist as a kind of masks that are imprinted
in the collective memory of the community. The artist stages naked
men having their time in a public bath behind men torturing another
person by water or stages himself as the athlete Lim Chun-ae. What
he asks through these ridiculous scenes seems to be a question that the
very masks on such historical memories are probably being distorted
by additional masks that come from our own memories.

조습(1975~)
JO Seub

물고문
Water Torture
2005(2007년 인화)
디지털 크로모제닉 컬러 프린트
Digital chromogenic color print
101×127cm
국립현대미술관 소장 MMCA Collection

임춘애
Lim Chun-ae
2005(2007년 인화)
디지털 크로모제닉 컬러 프린트
Digital chromogenic color print
101×127cm
국립현대미술관 소장 MMCA Collection

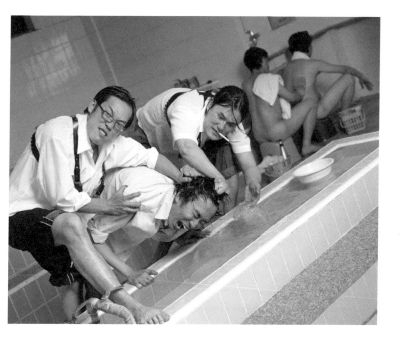

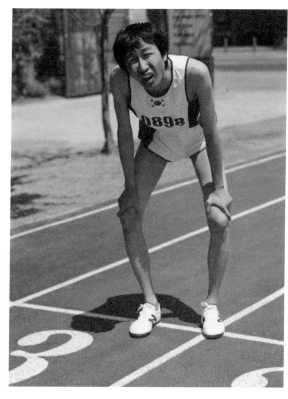

후지이 히카루는 특정 지역의 역사를 공부한 후 다양한 세대의 지역민들을 인터뷰함으로써 과거와 현재를 연결하는 작업을 한다. ‹일본인 연기하기› 는 ‘일본인 연기하기’를 주제로 워크숍을 진행하며 참여자들의 말과 행동을 영상으로 기록한 작업이다. 작가는 워크숍 참여자들에게 다른 이를 관찰하고 평가하도록 지시하면서 제국주의 시기 일본인을 연기하도록 하였으며, 이를 통해 당시 일본인들의 관점을 재현하고자 하였다. 그 과정에서 과거 일본인들의 제국주의적 시각과 현대 사회를 살아가는 참여자 개개인의 경험이 섞이게 되고, 지금은 사라졌다고 믿는 과거의 관념과 행동양식이 현대에도 어떤 모습으로든 존재하고 있음이 드러난다.

FUJII Hikaru creates artworks that connect the past with the present by examining the history of particular locations and interviewing local residents of different generations. *Playing Japanese* consists of video documentation of workshops where participants learned how to act and speak like Japanese. The artist instructed the workshop participants to observe and evaluate others, leading them to perform the Japanese people during the imperial period. By doing so, he attempted to represent the viewpoint of Japanese people at that time. In the process, the imperialistic viewpoints from the past and the experiences of individuals in the present are mixed together. This finally reveals that certain ideas and behaviors of the past that are believed to have disappeared still exist in different forms in the present.

후지이 히카루(1976~)
FUJII Hikaru

일본인 연기하기
Playing Japanese

2017

비디오 설치; 5채널 비디오, 컬러, 사운드,
17분 42초, 4분 56초, 7분 19초, 4분 56초, 6분 17초; 사진 5점
Video installation; five-channel video, color, sound, 17min. 42sec., 4min. 56sec.,
7min. 19sec., 4min. 56sec., 6min. 17sec.; 5 photos

국립현대미술관 소장 MMCA Collection

1991년 실기실에서 우연히 발견한 두개골 모형을 시작으로 작가는 알 수 없는 죽음을 맞이했을 실제 인물을 상상하며 작업을 시작했다. 그는 먼저 두개골을 다섯 개로 복제한 후, 동일한 골격에도 서로 조금씩 다른 모습의 젊은 여성을 상상하며 복원 작업을 진행했다. 그렇게 제작된 두상 중 하나에 특수 제작한 슬라이드 프로젝트로 작가 본인의 모습을 투사하여 마치 여성이 숨을 쉬며 되살아나는 듯한 장면을 연출했다. 작가의 상상력은 더 나아가 여성을 죽음에 이르게 한 원인과 이를 둘러싼 역사의 조각들을 찾아가는 것으로 확장되었다. 작가는 이념 혹은 종교의 대립으로 자행된 대량학살을 떠올렸다. 함께 놓인 얼굴 골격 측정기는 나치의 우생학을 상징하며, 작가 자신의 얼굴 실루엣을 따라 오려낸 세계인명사전은 권력과 이데올로기에 따라 인간을 우등·열등으로 재단해온 폭력적인 장치들을 연상시킨다.

In 1991, KIM Youngjin accidentally discovered a replica skull in his school's studio. Since then, the artist started creating works by imagining those who might have faced an unknown death. For *Montage-Beautiful Event*, KIM first created five replicas of the skull and worked on the restoration of faces, imagining young women with slightly different faces despite having the same skull. On one of the restored head figures, he projected his own face using a custom-made slide projector to reinvigorate it with vitality. With this work, the artist's imagination expanded to find the cause of the women's death and the historical fragments around it. The imagination reached genocides caused by ideological and religious conflicts. Placed along with the head figures, the facial bone measuring instruments symbolize Nazi eugenics. The *Dictionary of International Biography*, cut out in the shape of the artist's face, is reminiscent of violent devices that have categorized people into superior and inferior beings by the criteria of power and ideology.

김영진(1961~)
KIM Youngjin

몽타주-아름다운 사건
Montage-Beautiful Event

1991(2019 재제작)

유리진열장, 얼굴이 복원된 두개골 모형, 골격측정기, 세계인명사전, 슬라이드 프로젝터
Glass showcase, skull replicas, facial skeletal instrument, dictionary of international biography, slide projector

162.7×230×80cm

국립현대미술관 소장 MMCA Collection

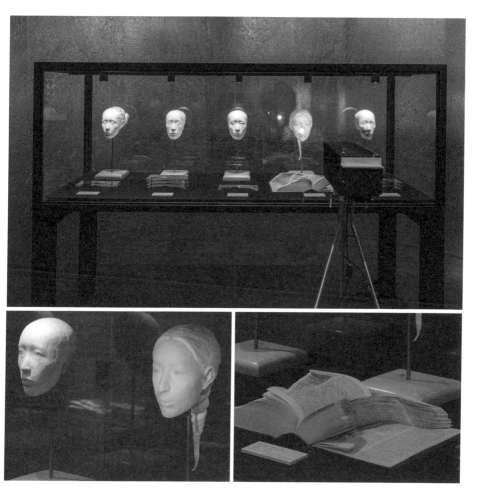

니키 리는 개인의 정체성이 시간과 공간을 따라 변화할 수 있다는 사실을 14편의 ‹프로젝트› 연작(1997–2001)으로 보여준다. 그중 ‹펑크 프로젝트›는 주류사회 속에서 별종 또는 망나니처럼 취급되는 '펑크족' 속으로 스며들어 옷차림, 행동양식, 심리 상태를 치밀하게 관찰한 뒤 그들의 내면과 외면을 작가 자신의 새로운 정체성으로 삼고 행동하며 그 장면들을 촬영하는 방식을 취한다. 그리고 그들의 문화와 동화된 자신의 모습을 스냅 사진으로 기록했는데, 사진 속의 펑크족 인물들 역시 작가를 자신들의 일원으로 생각하는 듯 자연스러운 포즈를 취하고 있다. 이 연작은 흉내 내기를 통해 가면을 쓰고 그 가면을 통해 다시 이해와 소통을 추구하는 이율배반적인 프로젝트다.

Nikki S. LEE articulates that an individual's identity can change over time and space through the *Projects* series (1997–2001) in fourteen episodes. For *The Punk Project*, LEE infiltrated into a group of punks who have been treated as being eccentric or rowdy by mainstream society. The artist closely observed their clothing, behavioral patterns, and psychological conditions, appropriating their inner minds and exterior appearance as her new identity. She then documented her actions with the new identity in photography. Her homogenization with their culture was captured with snap photographs. The punks in these photographs look spontaneous as if they considered the artist as one of their members. As a whole, *The Punk Project* is a self-contradictory project where one voluntarily wears a mask by mimicking others and seeks understanding and communication through the very mask.

니키리(1970~)
Nikki S. LEE

펑크 프로젝트 1, 2, 3, 5, 6, 7
The Punk Project 1, 2, 3, 5, 6, 7

1997

디지털 C–프린트
Digital C–print

(1) 74.8×100.2, (2) 71×53, (3) 53×71, (5) 71×53, (6) 74.8×100.2, (7) 71×53cm

국립현대미술관 소장 MMCA Collection

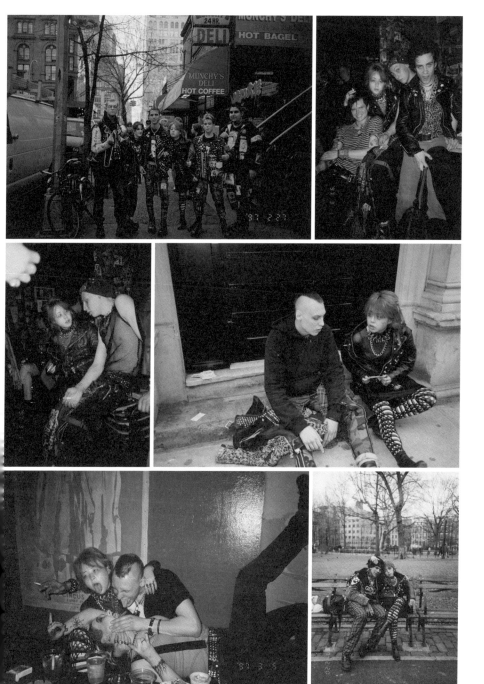

곽덕준의 <클린턴 곽-I>은 「타임」표지 위에 거울을 겹쳐들고 빌 클린턴(Bill Clinton) 미국 대통령과 자신의 얼굴이 겹쳐지는 모습을 바라보는 작가를 포착하고 있다. 세계에서 가장 정치적 영향력이 큰 인물과 자신을 동등하게 바라보는 시선은 이미지의 허구적 권력에 저항하려는 작가의 의지를 엿보게 한다. 이 사진에서 상대방의 가면을 쓰고 있는 것은 누구인가. 클린턴이 곽덕준의 가면을 쓰고 있는가, 아니면 그 반대인가. 사회적 가면과 개인적 실존 간의 경계를 의도적으로 흐림으로써 작가는 이 질문을 우리에게 던지고 있다.

KWAK Duckjun's *Clinton Kwak-1* shows a half of the artist's face reflected on a mirror, which is placed on the cover of *Time magazine* with US President Bill Clinton. The work presents a gaze through which the artist sees a person with the greatest political influence in the world on the same level. This gives us a glimpse into the artist's will to resist the fictional power of the image. Which person in this photo is wearing a mask? By intentionally blurring the boundaries between social masks and individual existence, the artist raises a question: Is Clinton wearing the artist's mask or the opposite is true?

곽덕준(1937~)
KWAK Duckjun

클린턴 곽-1
Clinton Kwak-1

1999

인화지 흑백사진
B&W photography

400×300cm

국립현대미술관 소장 MMCA Collection

이형구는 미국 유학 시절 서양인에 비해 왜소한 자신의 체형을 보완해 줄
독특한 장치를 고안함으로써 이방인으로서 겪을 수밖에 없었던 이질감을
역설적으로 표현했다. 여러 개의 돋보기로 직접 만든 특수한 헬멧을 쓰고
눈, 코, 입 부위를 확대하여 조금이라도 서양인의 외모에 가까워지려고
절박하게 노력하는 자신의 모습을 카메라에 담았다. 물론 결과적으로 남은
것은 마치 외계인처럼 괴상한 가면 같은 모습뿐이다. 어쩌면 서구의 기준을
따라잡기 위해서 엄청난 노력을 기울이는 한국 사회의 다양한 모습들 역시
이렇게 왜곡된 가면이 아닐까?

During his studies in the United States, LEE Hyungkoo created
unique devices to supplement his comparatively smaller body,
ironically expressing his alienation as an outsider. With integrated
magnifying glasses, the devices magnified the eyes and mouth. He
then documented his struggles to make himself look like his Western
peers. Of course, what remains is his bizarre look that resembles an
other-worldly figure. We might then ask ourselves about the immense
effort of Korean society to catch up with the Western standard as a
kind of distorted mask.

이형구(1969~)
LEE Hyungkoo

H–WR로 얼굴 변형하기
Altering Facial Feature with H–WR

2007(2009년 인화)

디지털 크로모제닉 컬러 프린트
Digital chromogenic color print

121×121cm

국립현대미술관 수장 MMCA Collection

안창홍의 <가족사진>은 마치 폐허 속에서 우연히 발견한 듯이 여기저기 긁힌 자국으로 가득한 빛바랜 사진처럼 보인다. 전형적인 가족사진의 틀과 다르지 않지만 무표정한 가면을 쓰고 있는 이들 가족의 모습은 마치 공포영화나 악몽에서나 보게 될 법한 모습이다. 표정을 잃어버린 이들은 이미 이 세상 사람이 아닌 것 같다. 아니면 그 어떤 가족도 그 어떤 존재도 피할 수 없는 죽음을 경고하고 있는 지도. 혹은 아직 광주의 비극적 기억에서 벗어날 수 없었던 1980년대 초라는 가혹한 시대에 기어이 살아남은 우리에게 역사가 건네는 준엄한 시선일지도 모른다.

AHN Changhong's *Family Photograph* depicts a faded photo full of scratches as if it was found by chance in ruins. The image composes a typical format of a family photograph, but the family resembles the ones that one might encounter in horror films or nightmares. The figures in the image seem to be out of this world with their expressions taken away. Maybe, they are warning the inevitability of death, which no family or person can avoid. Or, they represent the unyielding gaze of history to us who had survived the cruel period of the early 1980s when the tragic memory of what happened in Gwangju was still fresh in our memories.

안창홍(1953~)
AHN Changhong

가족사진
Family Photograph

1982

종이에 유채
Oil on paper

115×76cm

국립현대미술관 소장 MMCA Collection

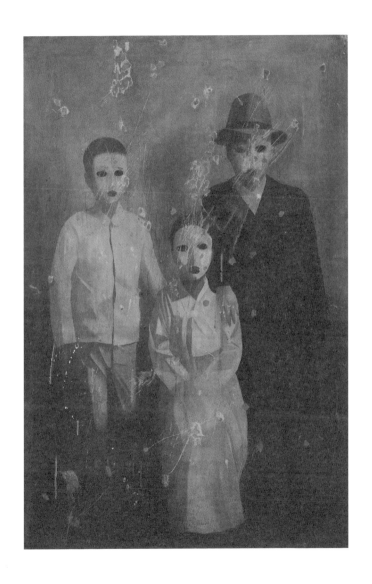

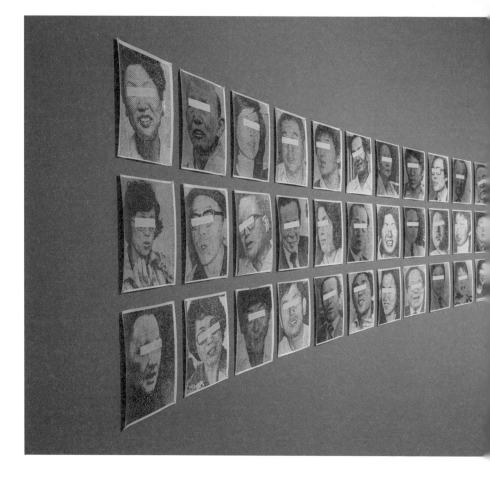

성능경(1944~)
SUNG Neungkyung

특정인과 관련 없음 1
No Relation to a Particular Person 1

1977

흑백사진, 브로마이드, 실크스크린
B&W photography, bromide, silk screen

25.3×20.3cm (110)

국립현대미술관 소장 MMCA Collection

성능경은 신문에 실린 다양한 얼굴들을 근접 촬영한 후 인화된 사진의 눈 부위에 노란색 띠를 붙였다. 작품을 제작하던 1970년대에는 범죄를 보도할 때 인물의 눈을 검은색 띠로 가리는 것이 관행이었다. 검은 띠로 눈을 가릴 때 이미 범죄자라는 의미가 부여된다. 이 판단은 오직 신문 편집자의 몫이었는데, <특정인과 관련 없음 I>은 이렇게 사회적으로 공인된 판단의 권위에 의문을 제기한다. 일률적으로 붙인 노란색 띠는 이것이 긍정적 의미인지, 부정적 의미인지, 이 사진이 실렸던 기사는 과연 어떤 것이었는지 모두 모호해지는 일종의 가면과 같은 역할을 한다.

To create *No Relation to a Particular Person 1*, SUNG Neungkyung took close-ups of people's faces in newspapers. He then put yellow tape on their eyes in the printed photos. In the 1970s, it was customary to cover the eyes of people with black boxes when reporting criminal cases in newspapers. The act of placing a black box in place of one's eyes indicated that the person was a criminal. It was up to a news editor whether to place the black box or not. SUNG Neungkyung produced *No Relation* to a *Particular Person 1* with an intention to raise questions on such judgment. The yellow tape, placed on the eyes of every person in the image, functions as a kind of mask that obscures the meaning of its own significance and the content of the original newspaper article.

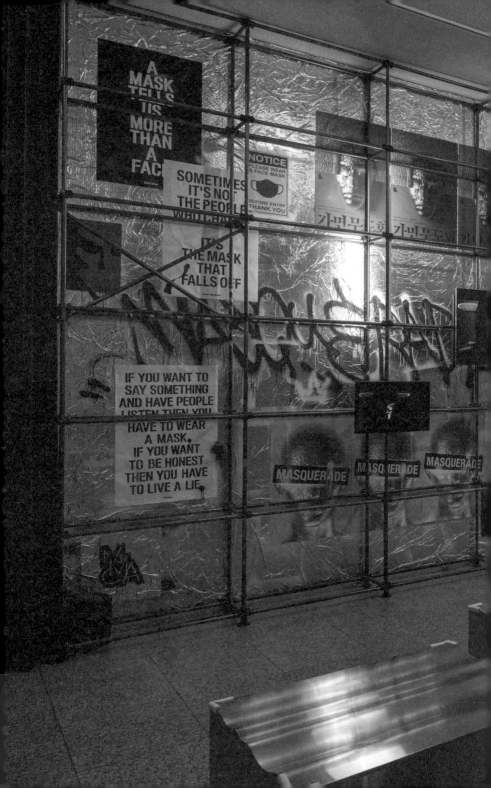

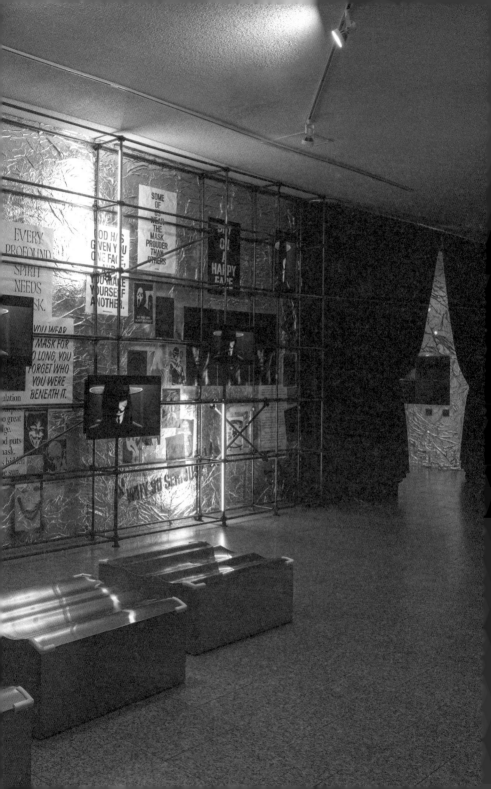

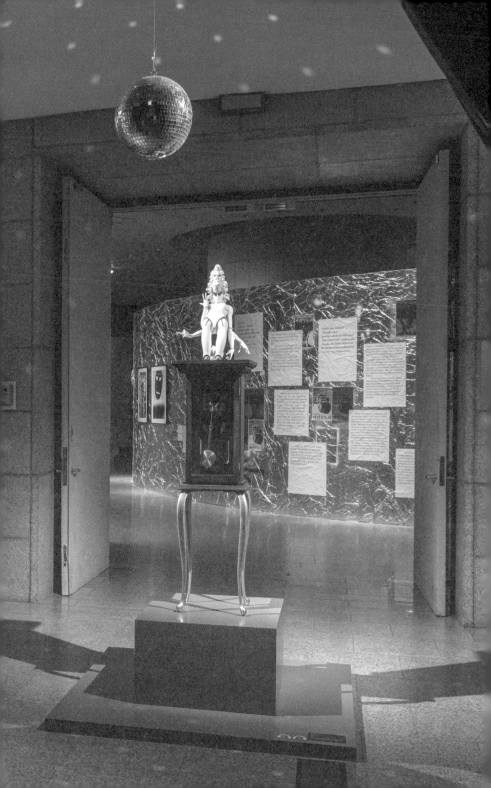

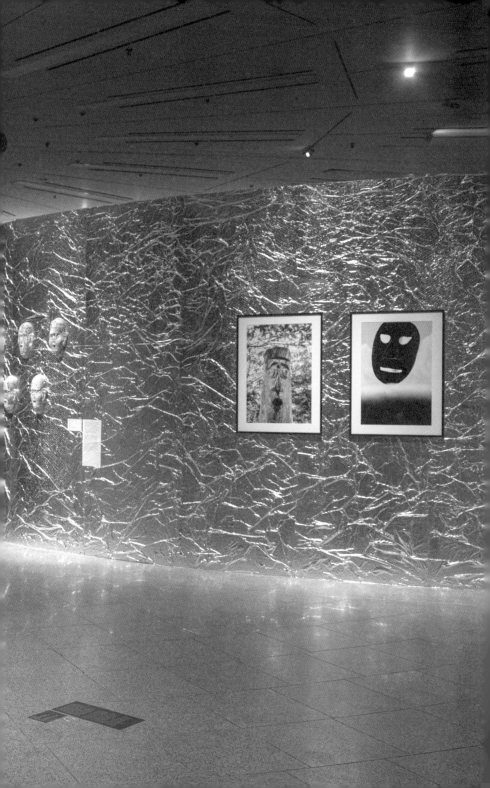

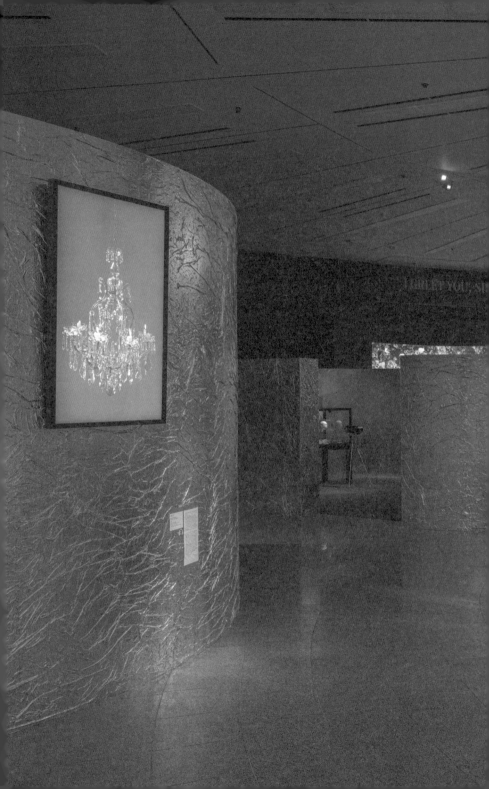

어제도 오늘도

가면무도회에

져 있지만, 나는 아노라,

© 2022 국립현대미술관

이 책은 국립현대미술관에서 개최된 «가면무도회»(2022. 4. 13. – 7. 31.) 전시 도록으로 제작되었습니다. 이 책에 수록된 작품 이미지 및 글의 저작권은 해당 저자와 작가, 소장처, 국립현대미술관에 있습니다. 저작권법에 의해 보호를 받는 저작물이므로 무단 전재, 복제, 변형, 송신을 금합니다.

발행처
국립현대미술관
경기도 과천시 광명로 313
02-2188-6000
www.mmca.go.kr

초판 발행
2022년 5월 30일

© 2022 National Museum of Modern and Contemporary Art, Korea
This book is published on the occasion of *Masquerade* (April 13 – July 31, 2022). All rights reserved. No part of this publication may be reproduced or transmitted in any form or by any means, electronic or mechanical, including photocopying, recording or any other information storage and retrieval system without prior permission in writing from prospective copyright holders.

Published by National Museum of Modern and Contemporary Art, Korea
313 Gwangmyeong-ro, Gwacheon-si, Gyeonggi-do, 13829 Korea
T +82-2-2188-6000
www.mmca.go.kr

First Edition
2022년 5월 30일

발행인 윤범모	**Publisher** Youn Bummo
편집인 김준기	**Production Director** Gim Jungi
제작 총괄 임대근, 조장은	**Supervisor** Lim Dae-geun, Cho Jangeun
글 임대근	**Contributor** Lim Dae-geun
편집 진행 임대근, 이현주, 김영인	**Edited by** Lim Dae-geun, Lee Hyunju, Kim Youngin Arial
교정 · 교열 윤솔희, 김영인	**Copyediting** Yoon Solhee, Kim Youngin Arial
도록 디자인 홍박사	**Editorial Design** hongbaksa
인쇄 및 제책 애드샵	**Printing and Binding** adsharp
영문 번역 서울리딩룸(박재용, 앤디 세인트 루이스)	**English Translation** Seoul Reading Room (Park Jaeyong, Andy St. Louis)
사진 장준호	**Photography** Jang Junho

ISBN 978-89-6303-167-5
값 20,000원